IMAGES
of America

COUCIL BLUFFS
BROADWAY

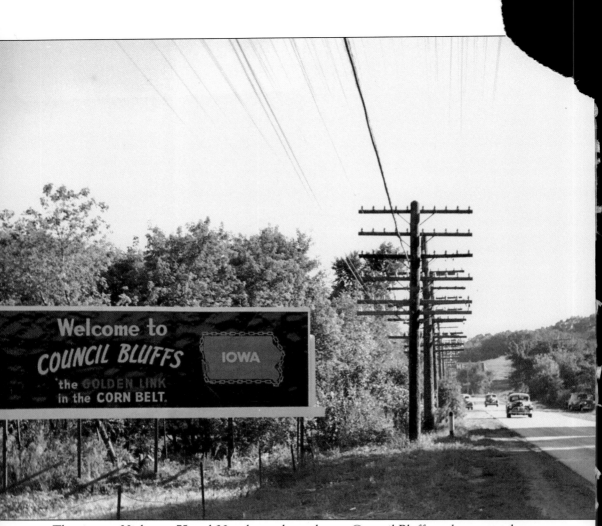

The sign on Highways 75 and 30 welcomed travelers to Council Bluffs as they entered town on North Broadway. (Courtesy of the Council Bluffs Public Library.)

On the cover: This snapshot of West Broadway and Sixth Street was taken by an unknown photographer on July 4, 1929. (Courtesy of the Historical Society of Pottawattamie County.)

IMAGES of America
COUNCIL BLUFFS
BROADWAY

Dr. Richard Warner and Ryan Roenfeld

Copyright © 2007 by Dr. Richard Warner and Ryan Roenfeld
ISBN 978-0-7385-5075-6

Published by Arcadia Publishing
Charleston, South Carolina

Printed in the United States of America

Library of Congress Catalog Card Number: 2007926279

For all general information contact Arcadia Publishing at:
Telephone 843-853-2070
Fax 843-853-0044
E-mail sales@arcadiapublishing.com
For customer service and orders:
Toll-Free 1-888-313-2665

Visit us on the Internet at www.arcadiapublishing.com

To the people of Council Bluffs, Iowa.

Contents

Acknowledgments 6

Introduction 7

1. The Birth of a Street and a City 11

2. The Heart of the City 19

3. Modern Times 45

4. Urban Renewal and After 89

5. Parades and Processions 113

6. People and Personalities 121

ACKNOWLEDGMENTS

The authors would like to express their appreciation to the Historical Society of Pottawattamie County; its current president, Teressa Sward; and past president Ralph Wright. All photographs in this book are courtesy of the historical society unless otherwise noted.

We would like to thank historical society member Council Bluffs police lieutenant Robert L. Miller whose contributions allowed us to show some refreshingly different glimpses of Broadway. Lieutenant Miller is the author of the book *A Selected History of the Council Bluffs Police: 1853–2003* and became an avid collector of photographs over the past several years while doing historical research. He has also been working to archive old police department photographs, some of which were taken at traffic accident scenes along Broadway in the 1950s through 1970s. We would like to thank Lieutenant Miller for generously giving us access to these images, the Council Bluffs Police Department for their permission to publish them, and the hardworking officers who took the photographs.

A big thank-you goes to Mary Carpenter and the reference staff at the Council Bluffs Public Library whose archives remain a treasure trove of information.

We are likewise most appreciative of the detailed information and photographs of Broadway's historic 100 block from Richard Miller, historical society member and chairman of the Historic Broadway Restoration Committee. Miller and his group have worked tirelessly to save what remains of the city's earliest business district, which was placed on the National Register of Historic Places in 2002.

Finally we would like to thank Mike Warner and Steven Warner for their technical assistance and equipment, our parents for taking us to downtown Council Bluffs as children, and Amanda Pokorski and Barb Warner for their help, encouragement, and tolerance of us as we worked to meet our deadlines.

INTRODUCTION

It was a hollow indistinguishable from many others in the loess hills off to the east and a bit north of where the Platte River flowed into the Missouri. A muddy stream, tepid and low in summers, flowed between the bluffs and out onto the Missouri River flood plain into a swamp that was seemingly replenished every time it rained more than four inches in the hills up north. But there was still something that attracted Billy Caldwell in the autumn of 1837 to move 15 or so miles above the Potawatomi's new Council Bluffs Subagency. Officially he was Captain Caldwell and had served in the British Indian Service during the War of 1812 and had become the spokesman for the Potawatomi that relocated west after Chicago was sold. The First Dragoons under Captain Moore then built the Camp Kearny blockhouse about halfway up the hill overlooking Caldwell's village.

It was in the blockhouse where Jesuit missionaries Felix Verreydt and Pierre-Jean De Smet set up operations in May 1838, and Caldwell gave them "four poor little cabins besides, made of rough logs; they are fourteen feet each way." Father De Smet proved disappointed in the friendly but largely uninterested response of the Potawatomi. According to De Smet, a network of roads led down the hollow from "Caldwells' camp" on the south bank of Indian Creek and led southwest and west over the Eight Mile Prairie to the issue houses and steamboat landing on the river and the fur trading camps on the "Musquito River." It was still "not uncommon to meet bears" in the vicinity, wrote De Smet along with "prairie-wolves" and "black mountain wolves" that carried off the Jesuits chickens.

Caldwell's role as spokesman for the Potawatomi's interests often attracted the hostility of U.S. government officials who were rarely happy with the information Caldwell had for them. Indian Agent John Dougherty dubbed him a "red coat savage at heart" as Caldwell firmly demanded that their annuities not be paid in blankets but in hard silver currency. It was at his village on Indian Creek where Caldwell died of cholera in the fall of 1841, and the Jesuit mission in the blockhouse closed by the end of that year.

Change was coming fast to the Missouri River, and in 1844, Elisha Stephens quit his job as blacksmith at the Council Bluffs Subagency to help lead the first wagon train west through the Sierra Nevadas into California. Then in early 1846, the Potawatomi relinquished their reservation at Council Bluffs in exchange for a new home in Kansas. At the same time, the first bands of Mormons began to find their way to the banks of the Missouri with hundreds more following behind them all the way from Nauvoo. For the next six years, the Mormons constituted the bulk of the area's population after Winter Quarters was established and the Grand Encampment scattered into dozens of smaller camps across the countryside, including

Henry Miller's in the hollow of Indian Creek. In December 1847, Miller and 200 other Mormons built a log tabernacle near present-day 222 East Broadway to introduce Brigham Young as the second president of the Mormon Church. After Young's departure, Orson Hyde was placed in charge at Kanesville and named "President of the Church east of the Rocky Mountains." Hyde became Kanesville's greatest booster after he began publishing the *Frontier Guardian*, the first newspaper printed that far up the Missouri River.

The Kane Post Office first opened in 1848 in a log building in Miller's Hollow near present-day East Broadway and Benton Streets, and a community gradually coalesced. That September, Pottawattamie County organized in Kanesville, the only real settlement on the Missouri Slope north of Missouri and west of Fort Des Moines. The location was well located to supply the wagon trains of Mormons still arriving from the east and convenient to the ferries on the Missouri River with the well-traveled route up to the winter quarters ferry going north through Mud Hollow, as North Broadway was still known. A coherent layout of Kanesville was first proposed by early 1849 when the *Frontier Guardian* assured readers that despite its location "upon the extreme borders of civilization" the town could provide "every article needed in the Gold Mines, from a crowbar to a sieve, from a barrel or sack of flour to the broadside of a baconed porker, can all be had here." The newspaper openly suggested the benefits of stocking "the frontier region with provision of every kind—supply the emigrants and gold diggers, and have plenty of means to buy their gold when they come back."

George Jewett was one of the many that passed through the "scruffy town" of Kanesville in 1849, and Indian Creek flooded (not for the last time), the *Frontier Guardian* reported, carrying off "fences, bridges, and tents; driving families out of their houses and stock from their beds." Nonetheless the mail stage began to arrive from the east via Fort Des Moines and by the end of the year the Mower and Sanford stage line opened a route to Kanesville from St. Joseph, Missouri. The *Frontier Guardian* continued to boost the location during the fall of 1849 and announced that Kanesville had "some six stores with large and unlimited stocks of goods . . . two Public Houses, a Bakery and Confectionary Establishment, Drug Store, four Wagon Shops, two Blacksmith's Shops, an Establishment for making Riding and Pack Saddles, Larrietts, Packing Bags." The newspaper also reported the local efforts "in favor of a great National Railroad . . . It is said that the prevailing opinion is, that Council Bluffs is the point where the railroad is destined to cross the frontier."

In 1850, William Edmunson found almost 600 people at Kanesville, which he designated as "near the lower end of the Council Bluffs." Years later, W. H. Taft would recall Kanesville as a "squalid looking straggling collection of log cabins—many of them with dirt roofs—at the base of those lofty bluffs which bound the river valley on the east . . . one street contained the stores, saloons, hotels, and most of the residences." Still, Loyal Waterhouse found the town "a smart little place" and by June the *Frontier Guardian* stated that the "number of California wagons that have crossed at this point is about 4,500 . . . 13,500 men and about 22,000 head of horses, mules, oxen, and cows." Then at the end of 1851, Brigham Young called the Mormons to abandon their camps on the Missouri River and finish the journey west to Salt Lake.

The gold rush had already changed Kanesville as the *Frontier Guardian* lamented in early 1852 that "when the church council was our only tribunal here, we had no grog shops—Indians were not allowed to stalk abroad on this side, and vice and confusion were comparatively unknown." However, as the Mormons prepared to sell their cabins and squatter claims and head west, the newspaper promoted Kanesville "the principle outfitting point for California, Salt Lake and Oregon" with over 1,200 inhabitants "in a beautiful ravine, in the edge of the bluffs, about two miles from the Missouri river . . . about 300 houses, 16 mercantile establishments; two drug stores; two printing offices; five hotels; four groceries; two jewelers shops; one harness maker; eight wagon shops; two tinsmiths, two livery stables; two cabinet shops; five boot and shoe makers; two daguerrean rooms; five practical physicians; nine attorneys at law; one gunsmith; one cooper; several ministers of different denominations; three barber shops; four bakeries; one mill; seven blacksmith shops."

This frontier optimism was disputed by Thaddeus Dean, who dubbed Kanesville "a hard old hole" where "every crack and corner is crowded" and the women were "a set of squizzles. All wear pants and short dresses and boots." In spite of the community's humble appearance and location "stuck among the gulches," in the eyes of Dr. Thomas White, the great mass of emigration across the Great Plains congregated by May 1852 when the newspaper claimed that "five or six thousand teams crossed the Missouri River, at the different ferries near here . . . and there are many thousands more around this vicinity, aiming to cross." The population plummeted after spring, and that June, Swiss artist Rudolph Kurz passed through and bought a grizzly bear pelt and the scalp of a Snake Indian for $5. At a public meeting in October 1852 the remaining citizens gathered to change the community's name to Council Bluffs City, which was confined for several more years to what William Earnshaw called "one street which followed every crooked ravine" that became Broadway.

One

THE BIRTH OF A STREET AND A CITY

On January 19, 1853, the Iowa legislature authorized Council Bluffs, and Kanesville was no more. With the Mormons gone the population plummeted in a wave of lawlessness as "every available building was ere long converted into a gambling and drinking hall" according to Dexter Bloomer. The city's first mayor resigned six months into office, the vigilance committee was the only law around, and the log buildings downtown burned to the ground twice.

But the plucky "Bluff City" persevered as brick replaced cottonwood, Col. Sam Bayliss created West Broadway's Fourth Street angle to ensure traffic passed in front of his Pacific House Hotel, and residents were able to gain legal title after the 42-acre "Old Town Plat" was made official. Nebraska Territory was opened across the river where enterprising Council Bluffs businessmen founded Omaha. The hordes of emigrants left plenty of money behind on their way west, and railroad surveyors came with promises of boom times ahead, including Grenville Dodge, who knew a good thing when he saw it and settled down for good.

The population was around 2,000 when civil war was declared and Dodge raised a regiment of volunteers. He was a major general before it was over and was named chief engineer of the Union Pacific as the transcontinental railroad became a reality. By 1870, the city was home to 10,000 people as the Chicago and Northwestern, the Chicago and Rock Island, the Council Bluffs and St. Joseph, and the Burlington and Missouri River Railroads had all rolled into town and mules hauled the omnibuses of the Broadway Street Railway down to the river ferries. The Union Pacific bridge opened in 1872, but the battle over the railroad's eastern terminus continued until 1875 when the U.S. Supreme Court decided in favor of Council Bluffs and citizens gathered at West Broadway and Fourth Street to celebrate. Before long, the city laid out Union Avenue running southwest to the Union Pacific Transfer from West Broadway and Ninth Street and Pacific Street running due south from West Broadway at what is now Twenty-first Street.

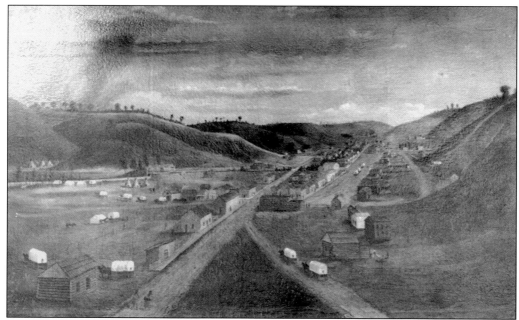

This painting is based on the George Simons sketch of Council Bluffs in the early 1850s showing the many businesses lining "uptown" East Broadway in the Indian Creek hollow where Kanesville had its start as well as the peculiar angle at Fourth Street as the street passes the "downtown" buildings at West Broadway at Pearl and Main Streets. (Courtesy of Richard Miller.)

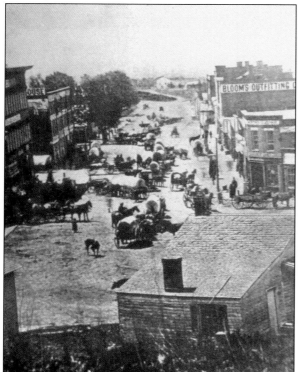

The businesses on Lower Broadway are seen from the hill above Fourth Street around 1864. Bloom's Outfitting was at the Pacific House, and the three-story Empire Block on the south side between Main and Pearl Streets was the home of Tootle and Jackson's Elephant Store near S. A. Meageath "Dry goods, notions, and Indian Goods," R. P. Snow's groceries and provisions, and the Island of Cuba Tobacco and Cigar Store.

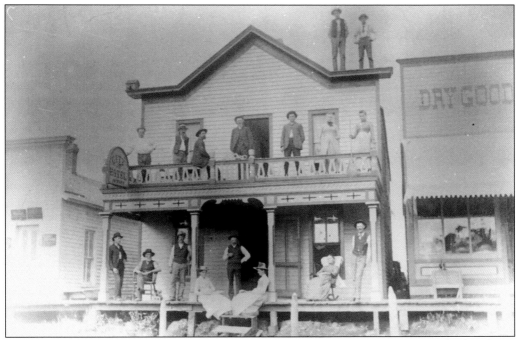

The City Hotel stood at West Broadway and Park Avenue. From 1859 to 1863, the hotel was operated by Hiram Shoemaker, an Illinois native who arrived in 1855, married English immigrant Mary Gardner, and was elected to the city council and as city assessor. Shoemaker later ran a meat market and then a confectionary before he got involved in real estate. (Courtesy of the Council Bluffs Public Library.)

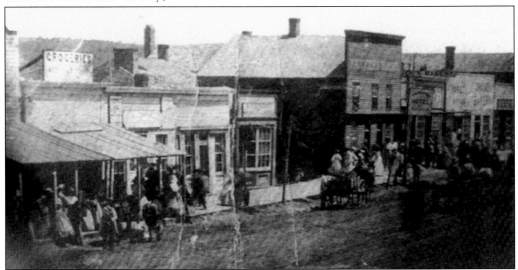

Bechtechle's Farmer's Hotel was on Middle Broadway, and on June 14, 1867, a mob from nearby Glenwood hauled William and Patrick Lawn out of their room and lynched them for "causing trouble" according to the 1881 *History of Mills County*. The Lawn brothers were Union veterans who returned at the end of the war to discover that the Glenwood Vigilance Committee had lynched their brother-in-law James Henderson in May 1865. (Courtesy of Lt. Robert L. Miller.)

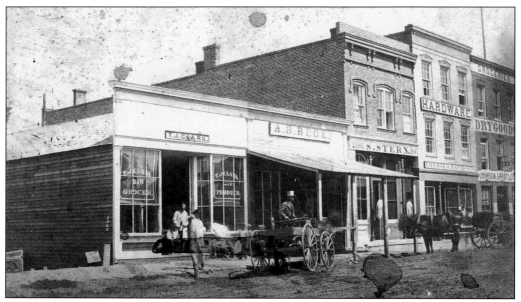

T. J. Clark's grocery; Imbrie and Davison Hardware; and Johnson, Spratlen and Company's dry goods store were in the 200 block of West Broadway during the 1860s. (Courtesy of the Council Bluffs Public Library.)

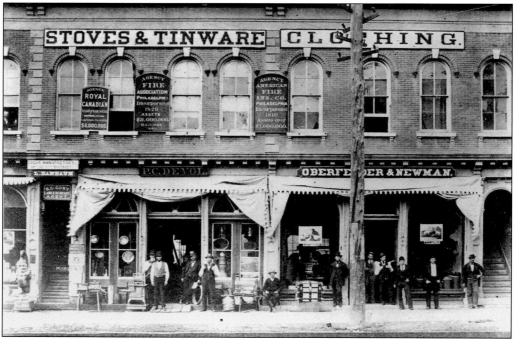

De Vol Hardware and Oberfelder and Newman's on Lower Broadway in the 1870s are shown with L. Danbaum's cigar manufactory and H. C. Cory's land and insurance business upstairs. Oberfelder and Newman employed over 20 tailors and 10 clerks at its Council Bluffs store with branches in Sidney, Nebraska; New York City; and San Francisco under the name Amazon Distilling. (Courtesy of the Council Bluffs Public Library.)

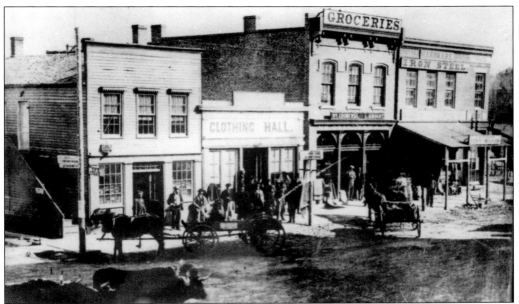

Cattle are in the streets in the above view of the businesses in the 400 block of West Broadway, including Bernard and Eiseman's Clothing Hall and the Groneweg and Kirscht grocery. William Groneweg and Leonard Kirscht were both German immigrants who went into business together in 1861 and offered free delivery throughout the city. Kirscht was a veteran of the Prussian army who was appointed captain of the C. B. Rifles militia in 1864, was elected to the city council in 1869, and served as president of the local Germania Society. Henry Eiseman bought out his partner and built his new building, seen below, in 1867. Groneweg sold out in 1878 and went into business with Belgian immigrant John Schoentgen, and Henry and Simon Eiseman built their new building down the street in 1889. (Above, courtesy of Lt. Robert L. Miller; below, courtesy of the Council Bluffs Public Library.)

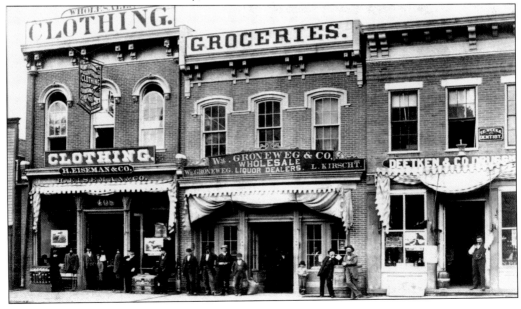

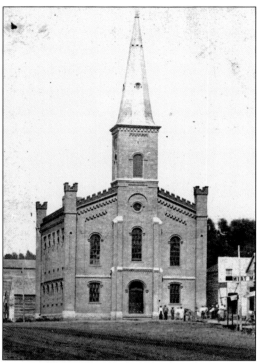

The Broadway Methodist Church is seen at West Broadway and First Street in 1868. Danish immigrant C. O. Mynster opened a store here in 1850 that became the infamous Ocean Wave Saloon. The lot was purchased by Henry Delong for $250 and donated to the church. The church was built for $25,000 and was replaced in 1892 by the present Broadway United Methodist Church. (Courtesy of the Council Bluffs Public Library.)

West Broadway, west of Fourth Street in the late 1870s, is shown with a prominent boot-shaped advertising sign. The Rankin Brothers, J. M. Phillips, and James Hulst were a few of the early boot and shoe dealers near West Broadway and Fourth Street in the days when Council Bluffs was a major outfitter for those headed west across the Great Plains. (Courtesy of the Council Bluffs Public Library.)

The Ogden House at 173 West Broadway was built by "uptown" interests in 1869 and named after William Ogden, Chicago's first mayor and the first president of the Union Pacific. The original Ogden House burned in 1874 and was rebuilt two years later. During the Great Railroad Strike of 1877, a "hooting collection and a motley crowd" marched up Broadway and demanded that Mayor John Baldwin buy them all supper, according to the 1881 *History of Pottawattamie County*.

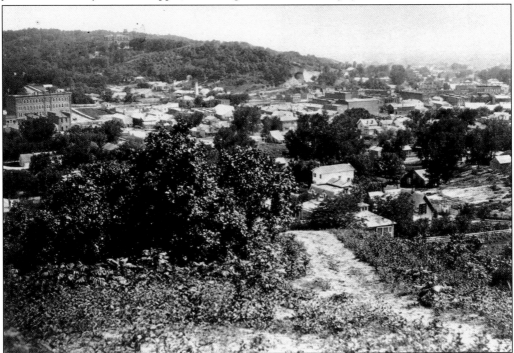

By the 1870s, Council Bluffs had spread out of the Indian Creek hollow and west through Streetsville to the ferries on the Missouri River. This view of the city shows the businesses along West Broadway west of the Ogden House Hotel. (Courtesy of the Council Bluffs Public Library.)

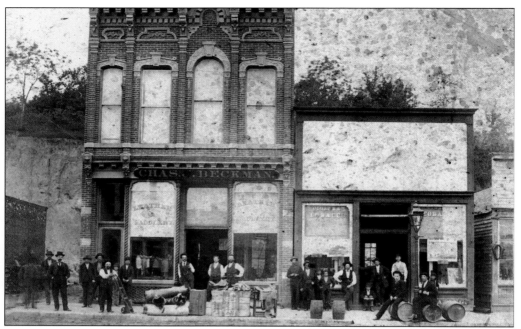

Charles Beckman stands at the entrance of his harness and saddle shop on West Broadway east of Fourth Street. Beckman immigrated to the United States from Bavaria and joined the 13th Illinois Infantry during the Civil War. He lost his right arm at the Battle of Mission Ridge, came to Council Bluffs in 1870, and moved into his new store in 1877. (Courtesy of the Council Bluffs Public Library.)

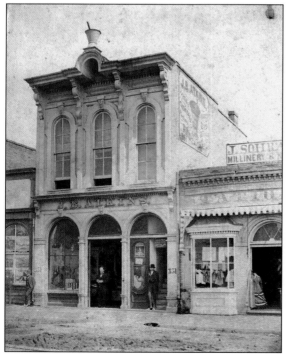

John Atkins's drugstore was on Middle Broadway. Atkins went to college in Detroit and first came to Council Bluffs in 1858. He served under Gen. Edward Canby in New Mexico during the Civil War. He ran drugstores out west before he returned to Council Bluffs. Atkins closed the business in 1903 and moved to Los Angeles where he died that December. (Courtesy of the Council Bluffs Public Library.)

Two

THE HEART OF THE CITY

The city's population was almost 18,000 by 1881 when the Missouri River flooded the city twice that April. In an effort to modernize, the city renamed the streets with those that paralleled Broadway on the north became lettered avenues and those on the south numbered avenues. West Broadway was paved with granite blocks between First and Twelfth Streets, and after 1885, cattle were no longer allowed to roam freely through town. A city waterworks was authorized; electricity, electric streetcars, and the telephone were all introduced. Mayor M. F. Rohrer used cedar blocks to pave West Broadway from Twelfth Street down to the river to celebrate the 1888 opening of the first pedestrian and wagon bridge to Omaha.

The Wabash, Milwaukee, and Great Western Railroads were all built into town while the Illinois Central had the Fort Dodge and Omaha and the Omaha Bridge and Terminal Railway built. Meanwhile Council Bluffs jeweler Maurice Wollman built himself the city's first automobile with a one-cylinder engine and the body of a buckboard wagon that newspapers labeled a "deadly juggernaut."

The population was over 25,000 in 1900 when Council Bluffs was the heart of the "Blue Grass region" of "vineyards, orchards and garden farms" known for "its fast horses and fine herds" according to the 1901 Polk's Iowa Gazetteer. Progress continued after Mayor Tom Maloney raised $14,000 to pave over the cedar blocks on West Broadway between Thirteenth and Thirty-seventh Streets. By 1912, the "metropolis of southwestern Iowa," as dubbed in a promotional pamphlet by McGee Real Estate, was estimated to have 35,000 people as a freight train left town every 11 minutes, and a passenger train was reported rolling into one of the city's depots every eight minutes.

At the same time, the city celebrated the opening of the Lincoln Highway between New York and San Francisco with the same enthusiasm shown the completion of the transcontinental railroad almost 50 years before. According to the 1916 *Clason's Guide to Iowa*, the transcontinental Lincoln Highway was joined by the King of Trails between the Gulf of Mexico and Canada; the River to River Highway, the Great White Way, and the Blue Grass Trail that all passed through Council Bluffs down Broadway.

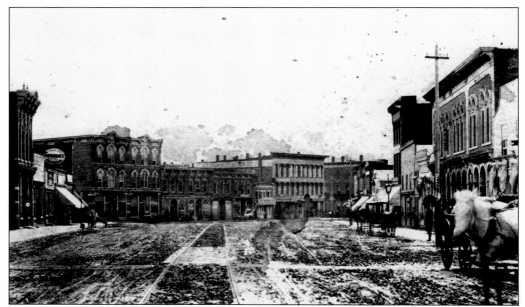

West Broadway's Fourth Street angle is seen in the 1880s. The Keller and Bennett Block at West Broadway and Fourth Street was built in 1876 and was home to the Boston Store and several other businesses before 1902 when the city's first Woolworth's five-and-dime store opened here. The Keller and Bennett Building was destroyed by fire in December 1922. (Courtesy of the Council Bluffs Public Library.)

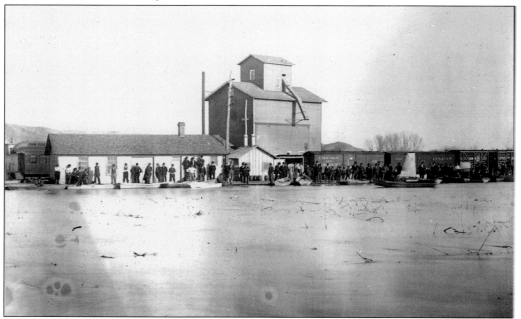

Boats lined up at the Chicago and Northwestern freight depot at West Broadway and Eleventh Street during the April 1881 Missouri River flood. During the flood it was possible to take a boat from the Northwestern depot all the way to Omaha as everything west of Twelfth Street was underwater. (Courtesy of the Council Bluffs Public Library.)

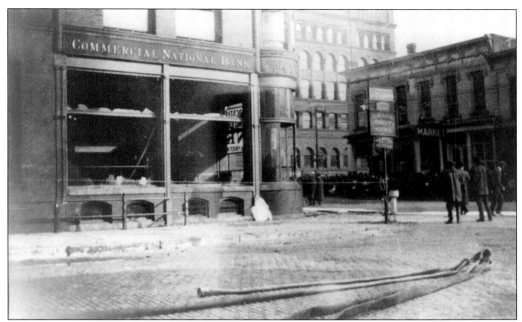

Shown is the aftermath of the March 1917 fire that swept through the Sapp Block and the Wickham Building, where it severely damaged S. S. Kresge's and Gunnoude and Zurmuehlen's cigar store.

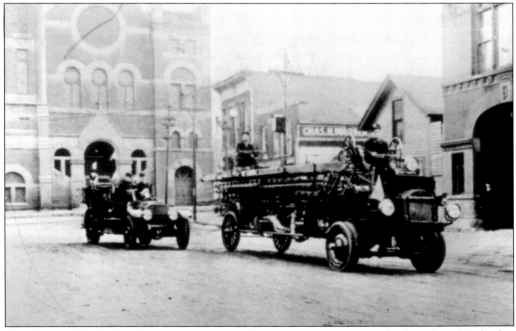

The Council Bluffs Fire Department shows off its new equipment near the Broadway Methodist Church at West Broadway and First Street. In the early 20th century, fire department Station 2 was at West Broadway and Twentieth Street, and Station 4, which is still is existence, was at East Broadway and Oak Street.

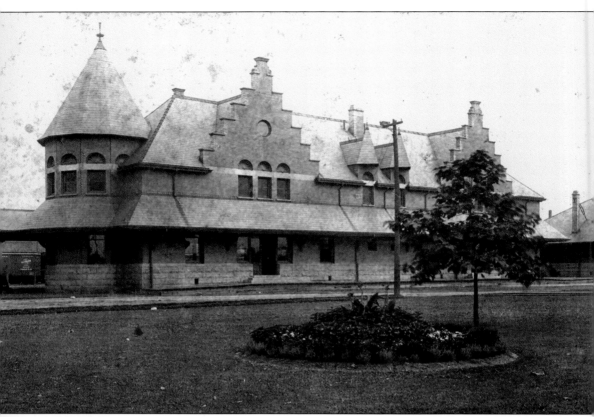

The Chicago and Northwestern passenger depot is shown at 1115 West Broadway in 1899. The Northwestern won the construction race across Iowa in January 1867 when it was the first railroad built into Council Bluffs from the east. Pres. William McKinley arrived here in 1898 on his way to Omaha's Trans-Mississippi Exposition, and Pres. Herbert Hoover spoke here the weekend before he was defeated by Franklin Roosevelt. The *Overland Limited*, *Chicago Express*, *Challenger*, and *City of Los Angeles* were some of the passenger trains that pulled in and out of this depot every day. (Courtesy of the Council Bluffs Public Library.)

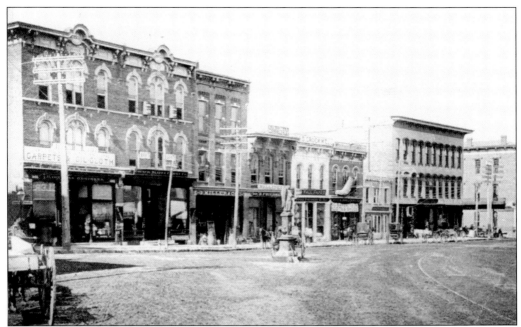

The south side of West Broadway along the Fourth Street angle shows such businesses as the Harkness Brothers' Headquarters Carpet Store, the Council Bluffs Carpet Company, H. Friedman's millinery, and J. D. Crockwell's wallpaper and book store.

The Bluff City Lodge of Masons was organized in 1855, and work began on the Masonic temple at West Broadway and Fourth Street in 1883. Construction was overseen by Danish immigrant Peter Wind, whose mill stood at West Broadway and Thirteenth Street next to the Mount Zion Colored Baptist Church.

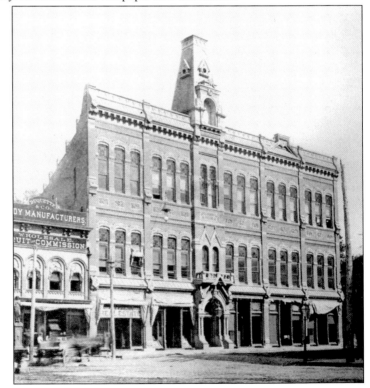

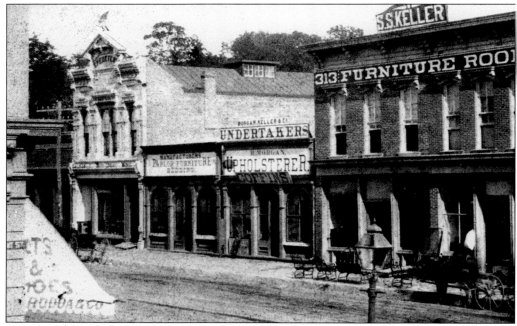

S. S. Keller's Mammoth Furniture House was at 313 West Broadway. Keller had served with the 156th Pennsylvania Infantry in the Civil War. In 1873, he entered the undertaking business with partners Morgan and Dohaney and moved his furniture business across the street into this building in 1881. The business continued into the 20th century as Continental-Keller Furniture. (Courtesy of the Council Bluffs Public Library.)

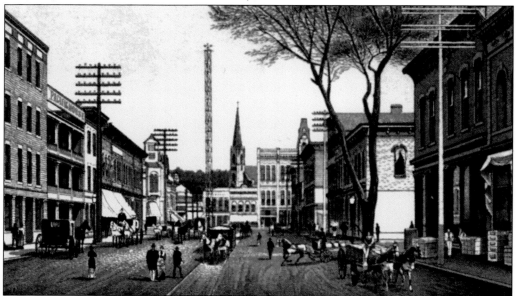

This late-1880s sketch is of West Broadway east of Sixth Street, including one of the city's 154-foot-high light towers placed around downtown in 1884. The tower at West Broadway and First Street collapsed in heavy winds in the fall of 1903, and the rest were sold for scrap shortly thereafter.

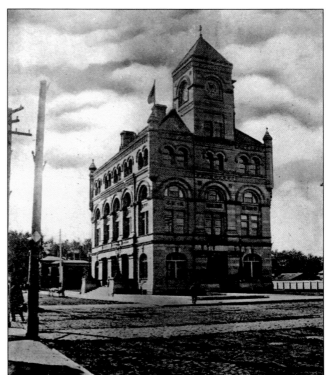

These two views are of the Council Bluffs Post Office and Federal Building at 603 West Broadway. The first appropriation for construction was made in 1883, and the building was completed by the end of 1888. One of those who came to Council Bluffs to assist in its construction was Charles Bell, a native of Illinois who was educated in Philadelphia.

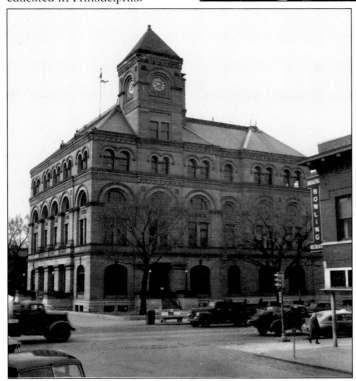

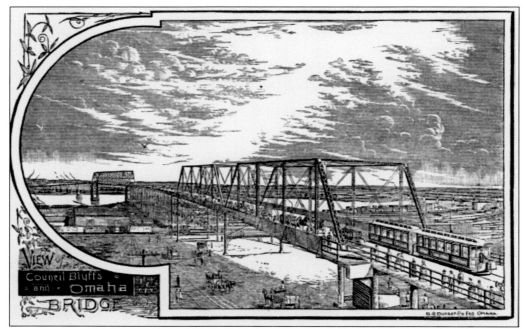

The Omaha and Council Bluffs Streetcar Company's Douglas Street Bridge opened across the Missouri River in 1888 to connect West Broadway with downtown Omaha. The bridge was 3,263 feet long and 33 feet wide, and businesses closed at noon on October 30 to celebrate. Passage was free on the first day, but afterward the toll was a dime for a horse and buggy and a nickel for pedestrians and passengers on the streetcar.

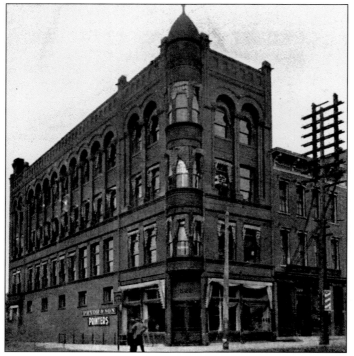

The Sapp Block at West Broadway and Scott Street was built in 1889 and was designed by Charles Bell. Bell and his partner John Kent later designed the county courthouses in Harlan and Manchester and the Montana state capitol building at Helena. Bell had offices on the fourth floor of the Sapp Block and in the Paxton Building in Omaha.

The Baldwin Block was also designed by Bell and stood at West Broadway and Pearl Street. It was completed by 1891, and John Baldwin sold the building to the Council Bluffs Savings Bank two years later.

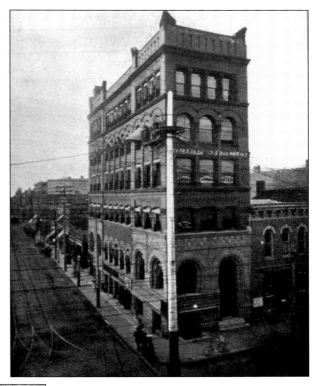

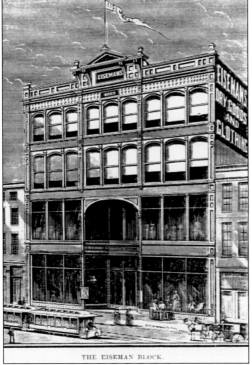

The Eiseman Block at West Broadway and Pearl Street was built in 1889 on the site of the original Pacific House Hotel. Simon and Henry Eiseman, two German Jewish immigrant brothers, opened their first clothing store in town in the 1850s. The building originally featured a large interior skylight and was purchased by John Beno and Company in 1900.

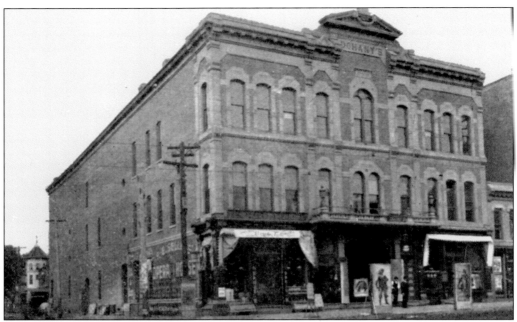

These two views are of the "new" Dohany's Opera House built in 1883 on the northeast corner of West Broadway and Sixth Street. This replaced the "old" Dohany a half-block off West Broadway on Bryant Street that opened in 1868. Located on the second floor of a livery stable, the 800-seat old Dohany hosted such 19th-century figures as the Reverend Henry Ward Beecher, Norwegian violinist Ole Bull, and "free love" advocate Victoria Woodhull. The 1898 season at the new Dohany opened with Al Field's minstrels packing the house to its 1,400-person capacity with the Chase-Lister Theater Company booked for the summer season.

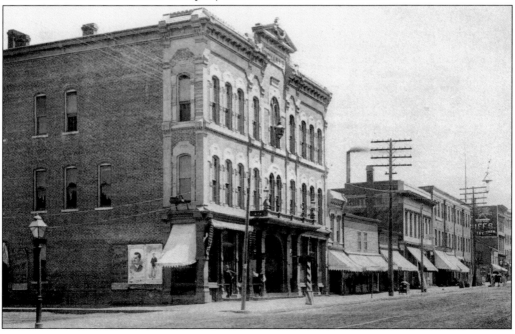

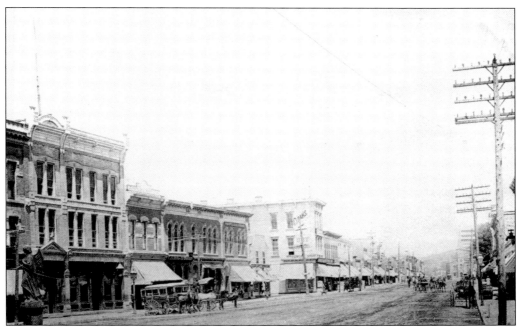

The north side of Middle Broadway is seen at the intersection of Bryant Street in the 1880s. Burhop's Hall was the home of the German's Turner Society. Two photography studios were also located along this stretch of the street during the 1880s, C. H. Sheridan's and Jennie Fleming's, which had been located on the corner of West Broadway and Bryant Street since she came to town in 1865.

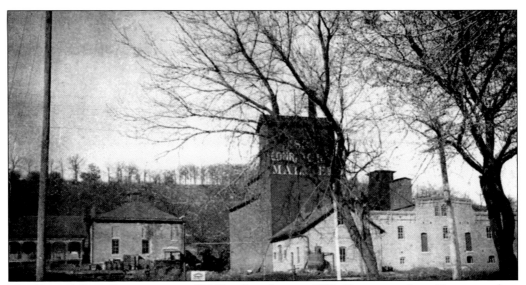

The Conrad Geise Brewery was at 800 East Broadway in 1898. Geise came from Germany when he was 16 and worked as a farmhand, in a brickyard, at Officer and Pusey's bank, and at Hagg's brewery. He built his own malt house and brewery in 1867–1868 and later expanded to produce 15,000 barrels of beer annually. He started bottling Pabst Milwaukee Beer in 1888.

Neumayer's Hotel at 208 West Broadway opened in 1882 after German immigrant Jacob Neumayer took over the Bryant House. Neumayer expanded in 1888 to compete with the 14 other hotels then operating along Broadway and rebuilt the structure after an 1897 fire. In 1898, Neumayer's offered 75 rooms for $1 to $1.50 a day and provided nearby stables with room for 150 animals.

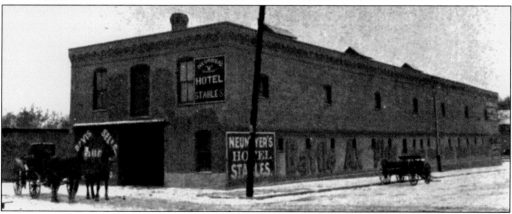

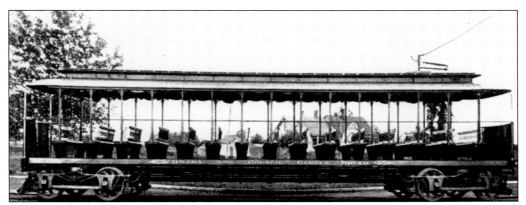

An Omaha and Council Bluffs Streetcar Company (O&CB) summer car was used to transport fun-seekers from downtown Omaha and Council Bluffs to Lake Manawa. The Manawa streetcars were run out of the Union Pacific's Broadway Depot at Ninth Street, originally built for the dummy train that ran between Council Bluffs and Omaha. The Broadway depot was home to the Council Bluffs Hatchery for most of the 20th century and was razed in 1995.

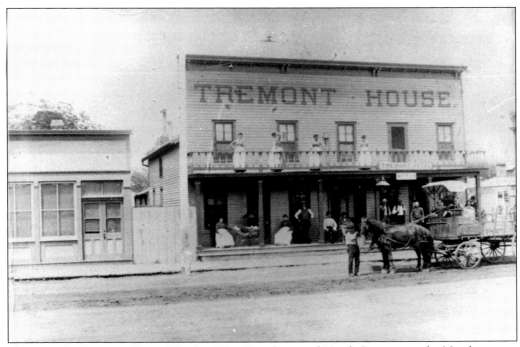

Shown is the Tremont House Hotel at West Broadway and Ninth Street near the Northwestern depot, the Union Pacific Broadway depot, the Metropolitan Hotel, and Belle Clover's bagnio at West Broadway and Eighth Street. Gerspacher's Union Avenue Hotel across the street served as headquarters for Canada Bill Jones's gang of bunco men in the 1870s and was where con men "Major" Williams, Mat Curran, and "Three-Fingered" Jack Roach killed James Hughes in 1885.

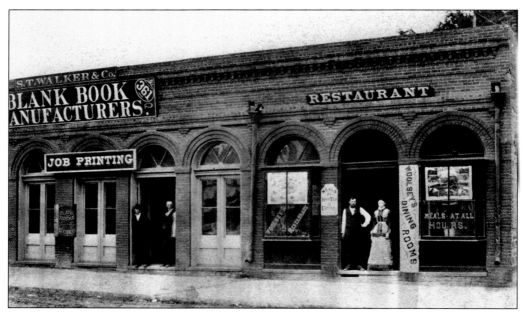

Bookbinders S. T. Walker and Company and Woolsey's restaurant, which promised "Meals at all hours," were on West Broadway west of Glen Avenue. Walker came to Council Bluffs from Ohio in 1857. Across the street was "medical electrician and gynechologist" Mrs. E. J. Harding, a graduate of the "Electropathic Institute of Philadelphia," who arrived in town in 1878 and operated the city's "only thermoelectric bath." (Courtesy of the Council Bluffs Public Library.)

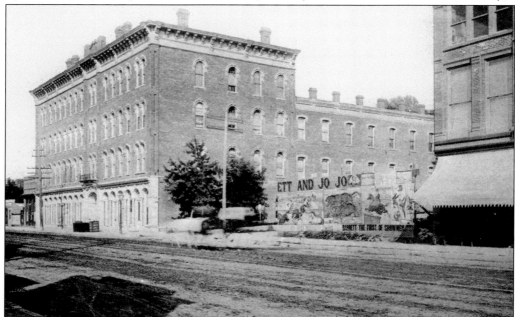

The rebuilt Ogden Hotel was at 171 West Broadway in the 1880s when Newton and Hatch's "saloon and oyster parlor" was a door east next to Stella Long's brothel at 151 West Broadway. The advertisement on the fence promotes Fedor Jeftichew, the Russian circus performer that P. T. Barnum brought to America as Jo-Jo the Dog Faced Boy.

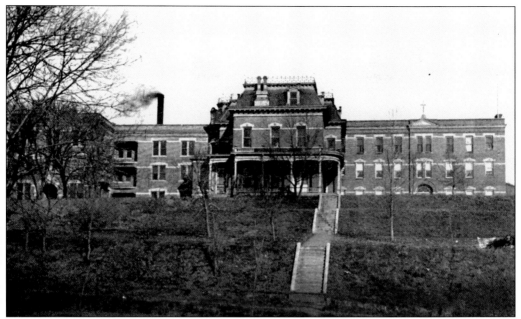

In 1888, the Conrad Geise mansion, which overlooked the intersections of East and North Broadway with Oak Street, became the new home of St. Bernard's Hospital and Sanitarium under the auspices of the Sisters of Mercy. Additional wings were built in 1890 and 1896. In 1903, the Sisters of Mercy opened Mercy Hospital at nearby Frank and Harmony Streets.

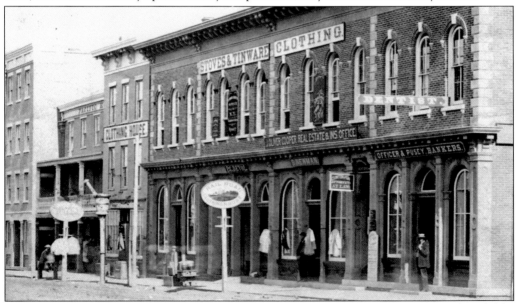

The old Pacific House that once towered over the cabins of early Council Bluffs is dwarfed by newer buildings housing De Vol's Hardware, Newman's Railroad Clothing House, and Officer and Pusey's Bank. The original hotel, built by Col. Sam Bayliss at the head of Pearl Street in 1853, was torn down in 1889 to make way for the Eiseman Block. (Courtesy of the Council Bluffs Public Library.)

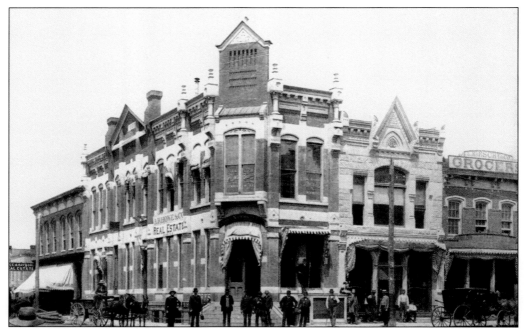

In the 1890s, the State Savings Bank was housed in the Kimball and Champ Building on the northeast corner of West Broadway and Main Street with Leonard Kirscht and Company still in business two doors east. Kirscht later moved to Omaha to run a wholesale liquor business until 1899 when he returned to the Bluffs and died two years later.

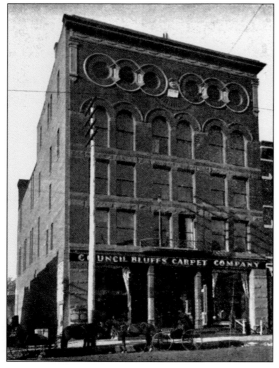

The Council Bluffs Carpet Company was housed in the International Order of Odd Fellows (IOOF) temple at 400 West Broadway. Lodge 49 of the IOOF was organized in town in 1853, and the five-story IOOF temple was built in 1896. In 1900, the *Daily Nonpareil* newspaper moved its offices into the building.

Oak Street marked the divide between East and North Broadway and was the location of the Oak Street School when this photograph was taken in 1898. The school eventually became St. Patrick's Catholic school.

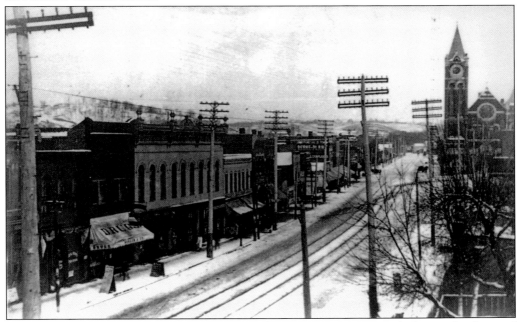

The north side of the 100 block of West Broadway is seen on a winter's day at the dawn of the 20th century. A few of the businesses then located here were dressmaker Monta Mottaz, Frank Napravnik's Boots and Shoes, James Plunket's machine shop, John Plunket's barbershop, Augusta Stabrei's women's furnishings, Amelia Nicoll's bakery, painter H. A. Musselman, Walter Brothers Harness, Preston and Utterback's Broadway Livery, and Rosenfeld and Unger's saloon. (Courtesy of Richard Miller.)

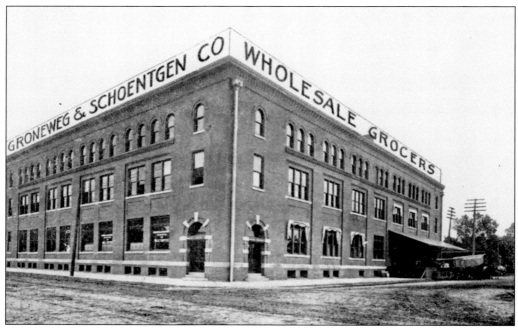

The Groneweg and Schoentgen Company building at 821 West Broadway was built in 1905. The partnership was established in 1878 by William Groneweg and John Schoentgen, who immigrated to Council Bluffs from Belgium. Groneweg and Schoentgen's wholesale business included the company's own line of Mogul Foods and Spices, and Groneweg was serving as mayor of Council Bluffs in 1887 when he was elected to the Iowa Senate.

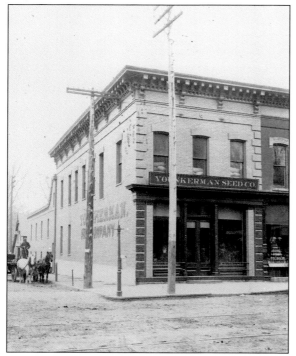

The headquarters of Younkerman Seed were at 164 West Broadway. Established in 1891, the wholesale and retail seed company offered "Everything in Field and Garden Seeds" along with "poultry, dog, and bird supplies." At the same time the offices of Shugart-Ouren Seed were at 320 West Broadway, and the national headquarters of florist J. F. Wilcox were at 521 West Broadway. (Courtesy of the Council Bluffs Public Library.)

This view is looking north on Pearl Street to the streetcar stop and the John Beno and Company department store at 508–514 West Broadway. A native of Alsace, Beno came to Council Bluffs via steamboat in 1861 and purchased the Eiseman Building in 1900. In 1910, John Beno and Company advertised its "Wholesale and retail dry goods, carpets, clothing, notions, men's and women's furnishings, millinery, etc."

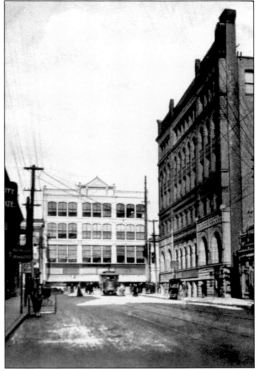

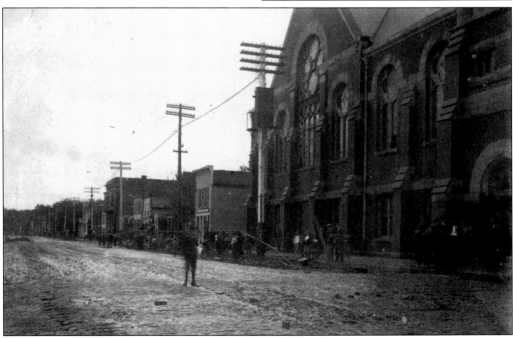

East Broadway, east of the Broadway Methodist Church, is seen around 1900 when the block was home to such businesses as Smith and Meisner Fuel and J. Zoller and Company. (Courtesy of the Council Bluffs Public Library.)

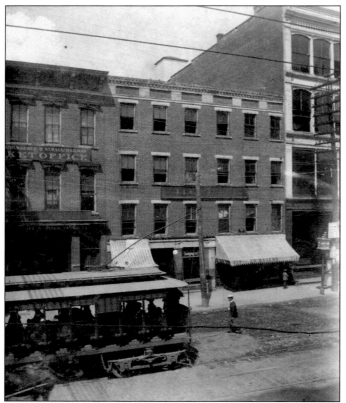

An open-air streetcar rolls past the New Pacific Hotel at 518 West Broadway. The New Pacific was built in 1872 as an addition to the Pacific House and offered patrons the luxuries of Ed Rogers's saloon shown below and the barbershop of German immigrant Fritz Bernhardi. Bernhardi served in the Prussian army during the war against Austria and was promoted to corporal in 1870 during the war with France. He was working as a barber on the Hamburg Steamship Line when George Keeline convinced him to move to Council Bluffs. In 1898, the New Pacific offered 45 rooms available for $1.50 to $2 a day and was known as the Hotel Inman before it was demolished to make way for the Wickham Building. (Left, courtesy of the Council Bluffs Public Library.)

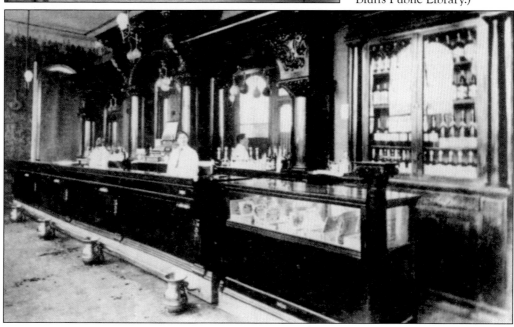

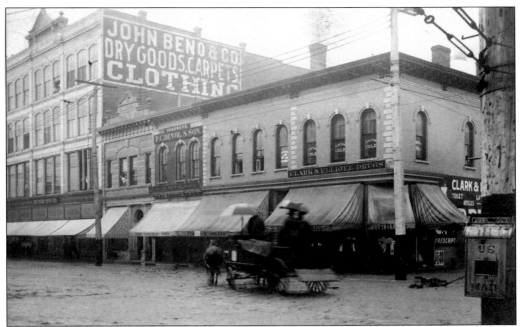

Water and mud cover the streets of Council Bluffs on August 26, 1904, after over a foot of rain fell in just 12 hours. The above view shows the northwest corner of West Broadway and Main Street. Below is the scene on West Broadway west of Tenth Street near H. H. Van Brunt's wholesale carriage and wagon warehouse, the Cuschocton Novelty Company, Fred Stephens restaurant and the saloon at 1028 West Broadway where Bert Forney was killed in a robbery the year before. (Courtesy of the Council Bluffs Public Library.)

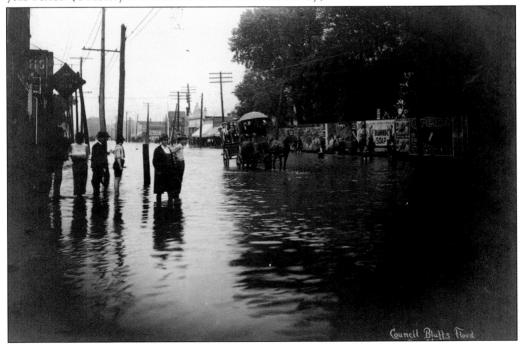

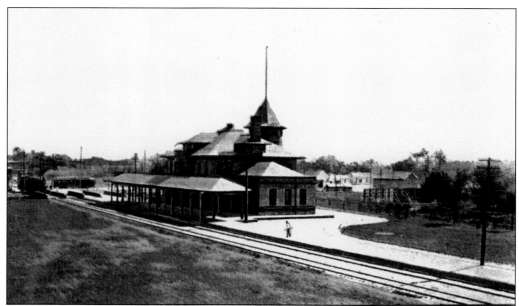

The Illinois Central passenger depot is seen at 1216 West Broadway. The 131-mile branch was built in 1899 as the Fort Dodge and Omaha Railway. The city granted rights to West Broadway along Twelfth and Thirteenth Streets as long as the railroad built a depot of brick or stone no less in size and not less substantial than the Northwestern. Both the Fort Dodge and Omaha and the Omaha Bridge and Terminal Railway were then consolidated into the Illinois Central. On September 28, 1911, Pres. William Taft appeared here as "2,000 citizens rubbed the sand out of their eyes at an early hour and gathered at the Illinois Central depot to greet the President" reported the *Daily Nonpareil*. On the south side of the street long stood the Union City Mission, which was established to serve the needy and the many transients that showed up in town.

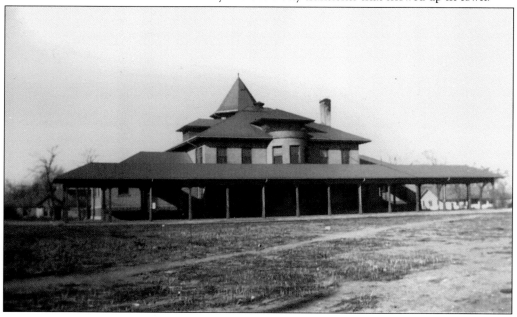

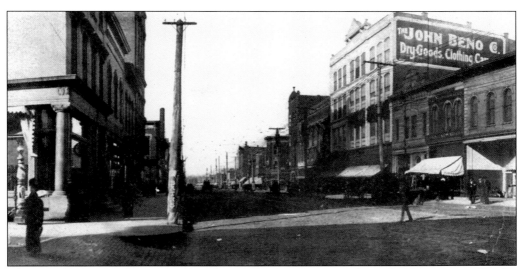

This view looks west down West Broadway from Main Street in the early 20th century. On the northwest corner stands the banking house of Officer and Pusey, which first opened in 1856 as the first banking house in western Iowa and the only bank in Council Bluffs that survived the panic of 1857. William Henry Mills Pusey was elected to the Iowa Senate in the late 1850s and served in the U.S. House of Representatives in 1883–1885. To the surprise of everyone, the bank closed in 1900 as Charles Officer was indicted for fraudulent banking practices and Pusey was taken to the Iowa Insane Asylum at Clarinda where he soon died.

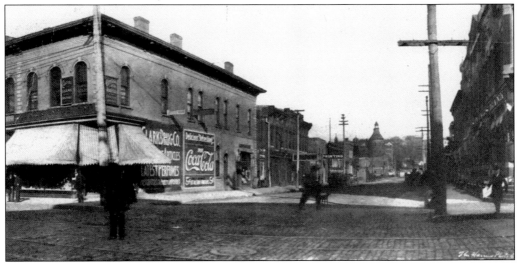

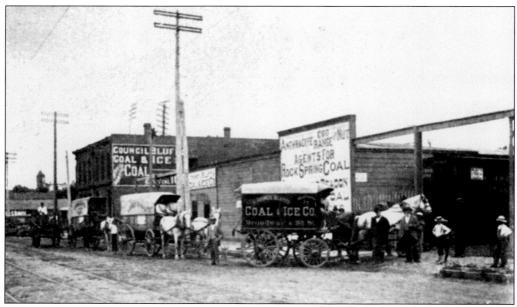

Delivery wagons wait to enter the yards of Council Bluffs Coal and Ice at 909 West Broadway. C. H. Chisam was manager in 1898 when the company delivered over 1,000 carloads of "anthracite and bituminous coal" a season with 24,000-ton capacity icehouses. During the 1930s, the company offered Dixie Coal for home delivery and promised, "Call 71 today—tomorrow you'll be a regular customer." (Courtesy of the Council Bluffs Public Library.)

A horse and buggy wait in front of Lathrop Novelty at 542 West Broadway around 1900. C. F. Lathrop was manager of the business, which offered "bicycles, etc." in 1901 when it was owned by Frank and Bertha Vredenburgh. (Courtesy of the Council Bluffs Public Library.)

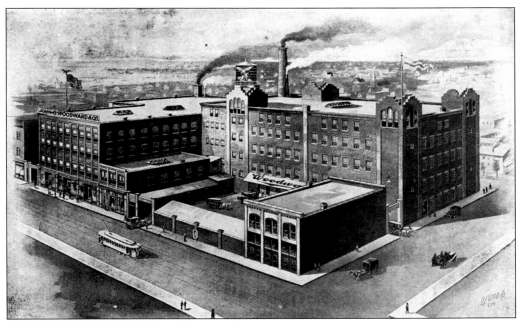

The John G. Woodward and Company's candy factory at 211 West Broadway was one of the first buildings designed by Danish-born architect J. Chris Jensen. Established in 1895, the business ultimately employed over 500 workers at the factory with 25 traveling salesmen on the road promoting their products as far west as Idaho. The envelope below boasts of the benefits of the Deborah Mineral Springs Lithia Water carbonated and bottled by Woodward's from its 850-foot-deep artesian well. By the early 1930s, Woodward's was distributed in 36 states and produced 3.5 to 5 million pounds of candy annually. The candy factory closed in 1938.

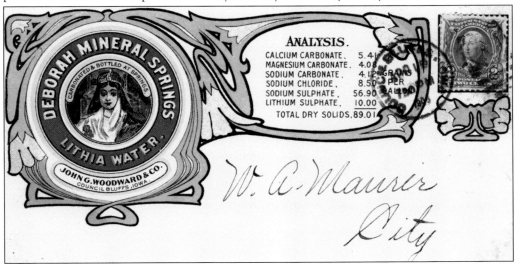

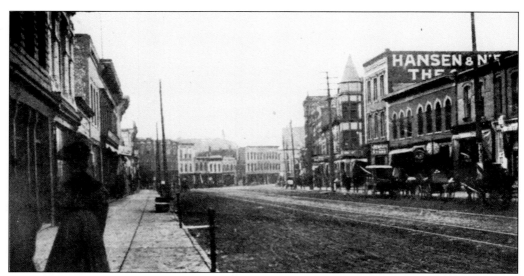

Streetcars and wagons with hitching posts line the street in these two views of West Broadway west of Glen Avenue near the dawn of the 20th century. The Sanborn Block at 326 West Broadway with its distinctive conical tower was designed by Charles Bell. Taylor Woolsey was still in the restaurant business along this stretch of West Broadway alongside such businesses as Seth May's saloon, Griesling's bicycle shop, N. P. Dodge Real Estate, Tom Maloney's cigar store, Jensen and Mortensen's grocery, Schmoller and Mueller's Music House, Swaine and Maurer's Hardware, Ole Rasmussen's wallpaper, and W. A. Maurer's crockery and china shop.

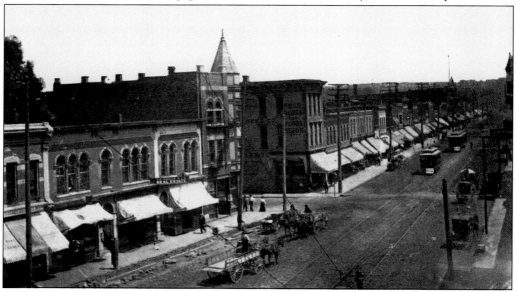

Three

MODERN TIMES

By 1920, the population of Council Bluffs was just over 37,000 when the cross-country highways that passed down Broadway included not only the Lincoln and King of Trails but also the George Washington between Savannah and Seattle and the Thomas Jefferson between New Orleans and Canada. After 1926 these early transcontinental routes down Broadway became U.S. Highways 30, 75, and 6, which was a featured part of Jack Kerouac's 1957 novel *On the Road*.

At the same time, Council Bluffs remained a major center of railroads with eight main trunk lines converging on the city by 1939 with 61 freight and 63 passenger trains leaving and arriving daily and over 2,200 railroad employees in town. World War II brought a variety of government contracts to businesses such as World Radio. Several floods occurred along Indian Creek, while gambling flourished at Meyer Lanksy's Dodge Park Kennel Club and along the South Omaha Bridge Road then situated just south of the city limits. The Missouri River threatened to flood out the city in 1943 and 1944 as the city's population grew to almost 45,500 by 1950, as the post–World War II baby boom took effect. Downtown Council Bluffs remained the major retail center of southwest Iowa with national chains and local stores alike lining Broadway. A viaduct was built over the railroad tracks between Eighth and Fifteenth Streets, and the city's population grew to 55,500 in 1960.

By 1960, cruising Broadway had become a favored pastime for teenagers from Council Bluffs, Omaha, and seemingly every one-horse burg around, and on Friday and Saturday nights the traffic was often bumper-to-bumper all the way down to Playland Park. While the automobile became ubiquitous, the railroads that had long been the city's lifeblood had declined, and the Northwestern's No. 5 passenger train to Chicago pulled out of Council Bluffs for the last time in March 1960. The 1968 opening of Interstate 80 took the transcontinental traffic passing through town away from Broadway.

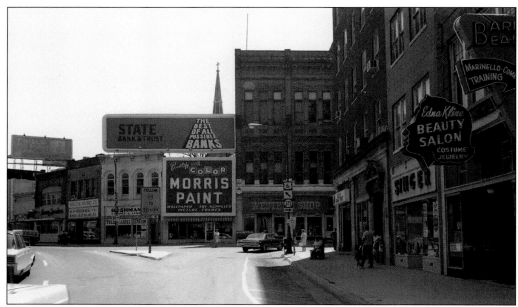

The spire of St. Peter's peaks above Lucey Jewelers, Walter Music, Bushman Carpets, Morris Paint, and the Western Store housed in the Masonic temple at West Broadway's Fourth Street angle. The traffic island was the original location of the horse trough that now stands at the intersection of Pearl and Main Streets. (Courtesy of Lt. Robert L. Miller.)

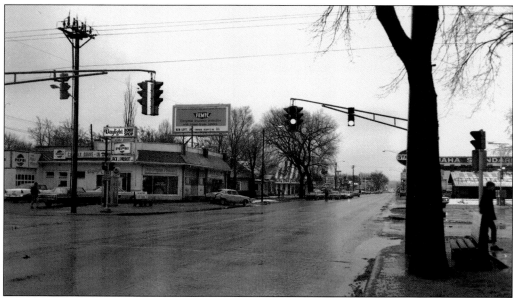

A policeman holds back traffic after this March 1969 accident involving the Studebaker Lark crumpled in front of the Daylight Donut Shop at West Broadway and Twenty-fifth Street. Just down the street is the Kentucky Fried Chicken take-home store that first opened on West Broadway in 1966. (Courtesy of Lt. Robert L. Miller.)

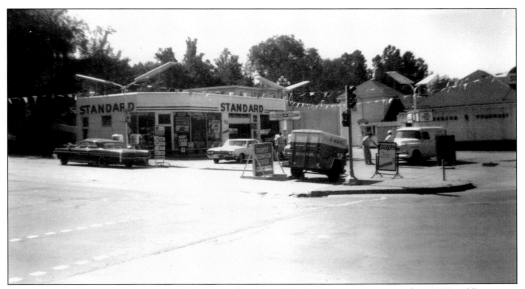

The Standard service station at East Broadway and Oak Street is seen in the 1960s. (Courtesy of the Council Bluffs Public Library.)

This view is of the Safeway Supermarket and Phillips 66 at 901 East Broadway during the late 1960s. (Courtesy of the Council Bluffs Public Library.)

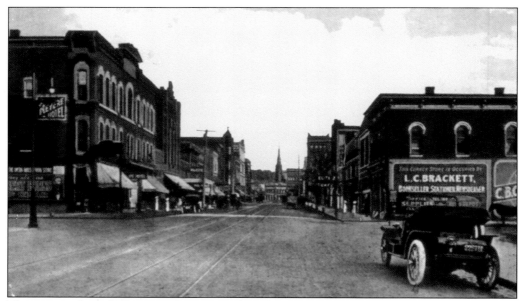

This postcard is of West Broadway east of Sixth Street in the 1920s. According to the 1924 *Official Road Guide of the Lincoln Highway Association*, $300,000 had been spent to improve the highway through Council Bluffs, which boasted "over 50 miles of paved streets."

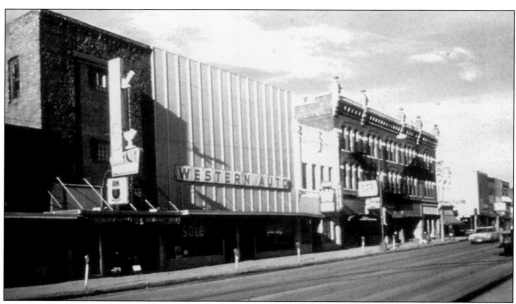

Located on the north side of the 300 block of West Broadway in the late 1960s were Don's Cafe and Lounge, which featured Hamm's on tap; Western Auto; the Club 212-Pizza King; and the Bluffs Hotel, formerly Neumayers. (Courtesy of Dr. Robert Warner Jr.)

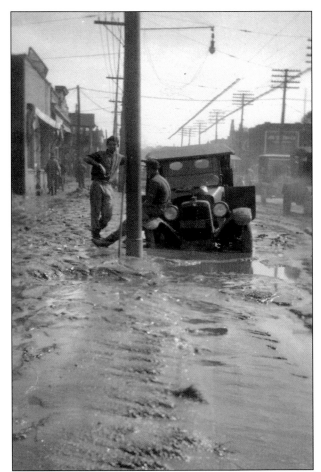

An automobile is mired in the mud near the Illinois Central tracks at West Broadway and Twelfth Street, and a man wades in water past his knees at West Broadway and Eighteenth Street after the September 1923 thunderstorm brought heavy rains and a tornado that killed five people. (Below, courtesy of the Council Bluffs Public Library.)

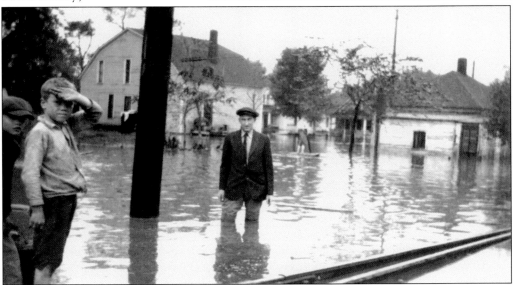

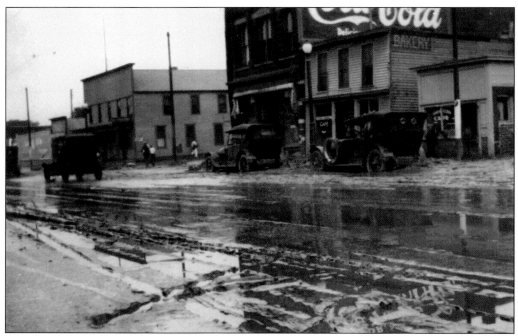

Another scene following the September 1923 thunderstorm shows the Northwestern Cafe and Bakery and the American Cafe on West Broadway near the Chicago and Northwestern depot. (Courtesy of the Council Bluffs Public Library.)

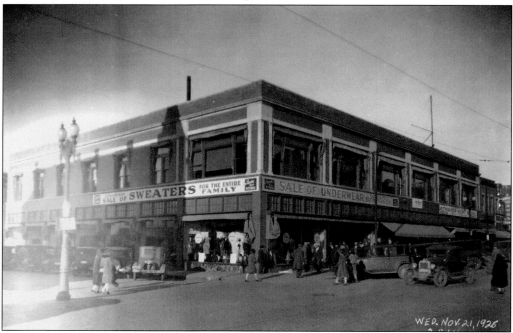

The pre-Christmas shopping season had already started for these shoppers flocking to People's Department Store at 312 West Broadway in this photograph taken on Wednesday, November 21, 1928, at 3:00 in the afternoon. (Courtesy of the Council Bluffs Public Library.)

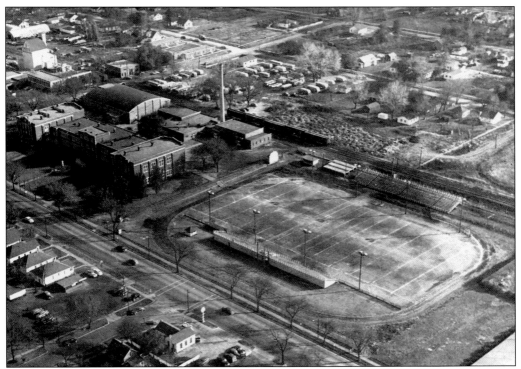

These two views are of Thomas Jefferson High School at 2501 West Broadway. The *Daily Nonpareil* reported that an additional $200,000 worth of bonds needed to build the city's second high school was passed in a November 1919 vote "wholly by the vote of the Fifth and Sixth Wards" in the west end of the city. The new school was dedicated in January 1922. A few alumni include Bill Smith who won the gold medal in wrestling at the 1952 Olympics, etiquette expert Marjabelle Young Stewart, former historical society president Ralph Wright, current Council Bluffs mayor Tom Hanafan, and Anna Mae Ross, the first black woman to graduate from the Creighton University School of Pharmacy in Omaha.

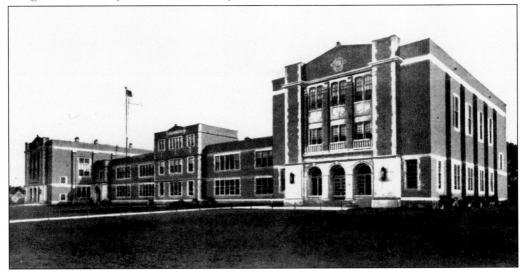

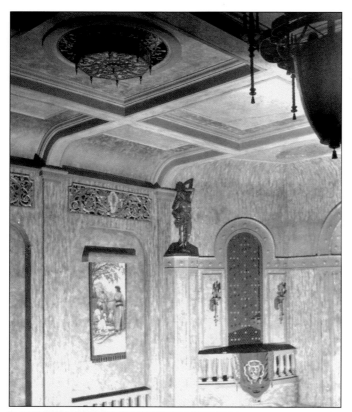

This photograph shows the interior of the Strand Theater at West Broadway and Sixth Street after Henry Schneider's elaborate 1927 remodeling project of what had been the Dohany Opera House. (Courtesy of Kathleen Rollins.)

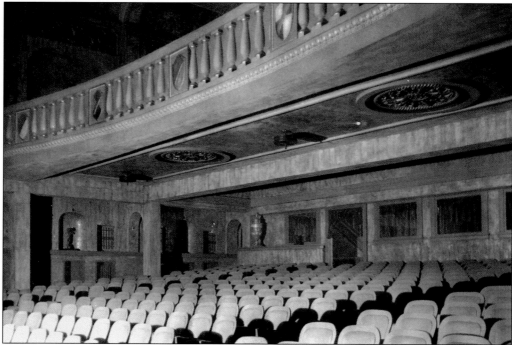

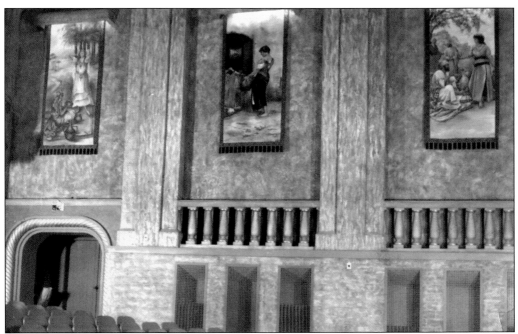

Another interior view of the remodeled Strand Theater is seen along with an outside look at the Taffe Drug Company, which supplied both patrons of the Strand and passersby on West Broadway with Sealtest Ice Cream, Coca-Cola, and more. For many years a jewelry store also operated at the remodeled Strand Theater. (Above, courtesy of Kathleen Rollins.)

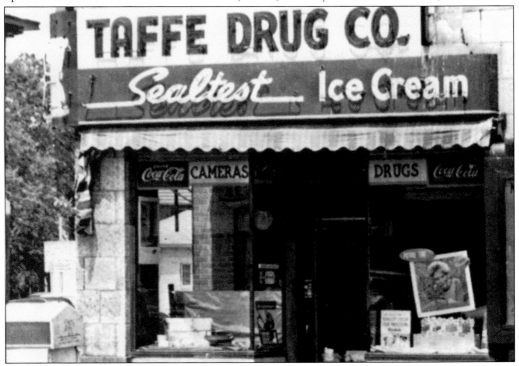

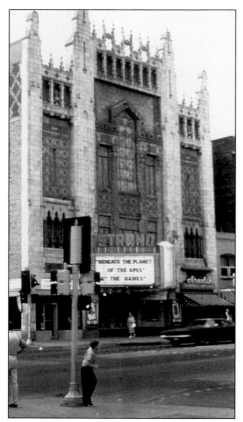

The Strand Theater also housed the studios of radio station KSWI, which went on the air in 1947, and the movie screen was converted to a Cinema-Scope wide screen in 1954. *Beneath the Planet of the Apes* had top billing at the Strand (left). On December 11, 1974, an electrical fire destroyed the interior and caused the roof to collapse. Although the seven-story, glazed-tile facade was only minimally damaged, it was feared that it would fall into the street so traffic was routed off West Broadway until it was demolished. Despite the untold thousands who had been entertained here during the previous 92 years, the Strand had closed early the night of the fire as not a single patron turned out for the final double feature, *Jeremiah Johnson* and *The Macintosh Man*. (Below, courtesy of Dr. Robert Warner Jr.)

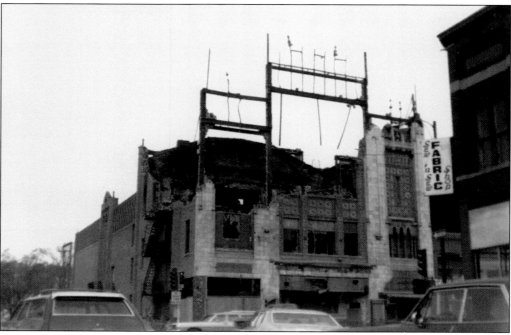

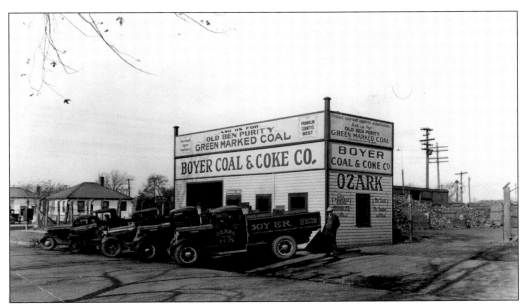

Boyer Coal and Coke Company at West Broadway and Twenty-fourth Street is shown during the 1920s. The business was owned by Charles Boyer, who came to Council Bluffs from Pacific Junction and built his home at nearby 2410 West Broadway. Boyer's house is now the home of Midlands Animal Clinic. (Courtesy of the Council Bluffs Public Library.)

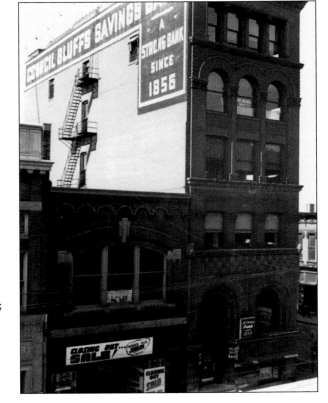

The Council Bluffs Savings Bank in the Baldwin Block at West Broadway and Pearl Street was first established by Nathan P. Dodge in 1870. In addition to Dodge, some of the other notable figures associated with the Council Bluffs Savings Bank included Augustus Beresheim; George Keeline, who built a cattle empire in Colorado and Wyoming; and M. F. Rohrer, who became mayor of Council Bluffs after William Groneweg was elected to the Iowa Senate.

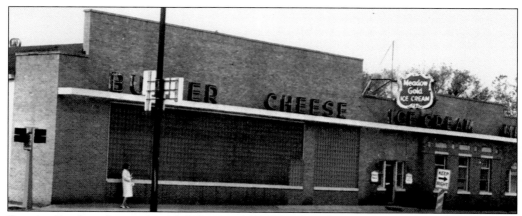

Beatrice Foods took over the A&S Dairy at 1607 West Broadway in the 1930s. Known originally for its Meadow Gold dairy products, the company eventually acquired such diverse brands as Avis Rent-A-Car, Samsonite, and Culligan. The company was taken over in a leveraged buyout in 1986, and a McDonald's presently occupies the site of the old dairy on West Broadway.

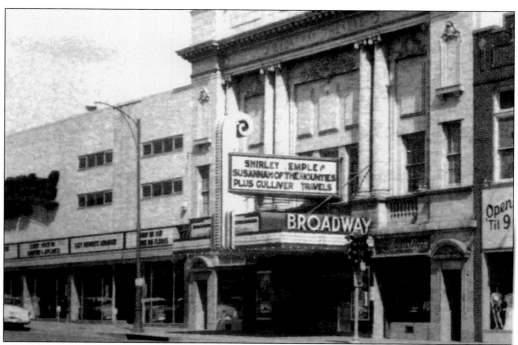

The Broadway Theatre is seen at 317 West Broadway. The Broadway opened in 1923 in the Beaux Arts building designed by J. Chris Jensen with Walter Davis as manager. Other early staff included "eminent organist" Ralph Hix; usherettes Ilda Spurgin, Esther La Rue, Mary Ludwig and Flora Wehrhahn; and porters Sam Forrest and Leonard Jones. Julius Rosenfeld was in charge of the Broadway in 1929 when talkies were first introduced.

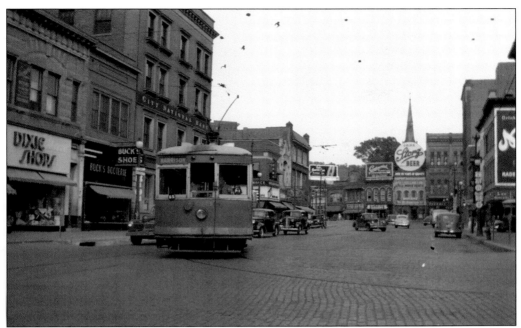

These two views are of O&CB streetcars on West Broadway east of Scott Street in the 1940s with Storz Beer advertised at the Fourth Street angle. Businesses on the north side of the street include S. S. Kresge's 5 to 25 Cent Store at 516 West Broadway, the John Beno Company, and City National Bank. On the right is the marble facade of the Council Bluffs Savings Bank and the State Savings Bank at 509 West Broadway, which was placed on the National Register of Historic Places in 1984. Operations of the O&CB came to an end in Council Bluffs by 1948, although the company continued to run its streetcars in Omaha until 1955. (Above, courtesy of the Council Bluffs Public Library.)

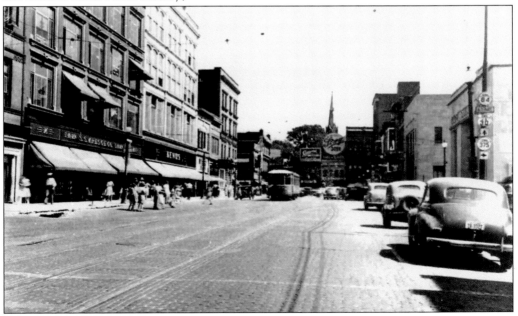

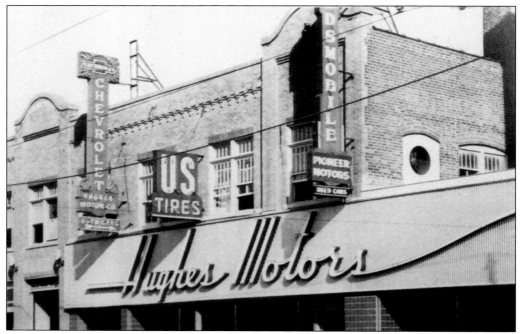

Designed by J. Chris Jensen, the Hughes-Iron Building at 153 West Broadway housed the city's first Ford dealership in 1916. Hughes left for World War I and returned to sell Chevrolets here until 1980. Carl Huber ran the Lincoln Highway Garage at 111 East Broadway, and in the 1930s, Hudsons and Terraplanes were available at Atlantic Auto at 149 West Broadway, with Pontiacs and Buicks sold at Sulley Motor at 126 East Broadway.

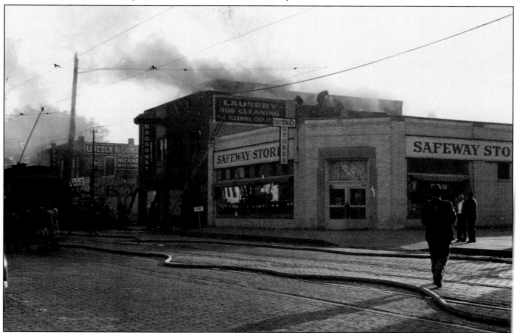

Fire strikes Broadway Cleaners and Laundry and Safeway Store No. 530 at 125–129 West Broadway.

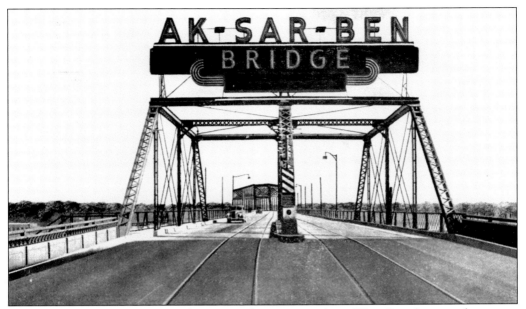

The O&CB Douglas Street Bridge across the Missouri from West Broadway to downtown Omaha became the Ak-Sar-Ben Bridge in 1936. Tolls were finally abolished in 1947, and by 1956, the bridge was used by over 33,000 vehicles daily. The 1888 bridge was closed to traffic in 1966 and torn down two years later.

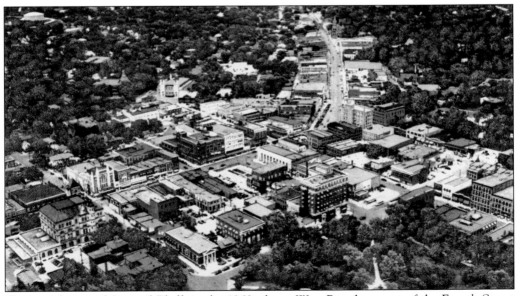

This aerial view of Council Bluffs in the 1960s shows West Broadway east of the Fourth Street angle and East Broadway with North Broadway turning north into the loess hills up what was once known as Mud Hollow.

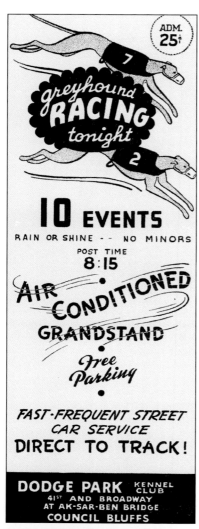

The 1938 Centennial Exposition was a bust and left Council Bluffs in debt. A solution was provided by Meyer Lansky and Bill Syms, who paid off the $8,000 debt and leased the grounds at West Broadway and Forty-first Street from the city for $1,700 a week to open the Dodge Park Kennel Club. A $50,000 grandstand and track were built before opening day on July 11, 1941, when 4,500 people showed up to bet on the greyhounds. Success led to 60 nights of racing in 1942 and 86 nights in 1943, and then newly elected Mayor Byers shut it down in 1944. Lansky and Syms attempted to reopen in 1946 but were blocked by the Iowa Bureau of Criminal Investigations. In spite of Lansky's reputation, Council Bluffs park commissioner Harold Gugler called him "a fine fellow."

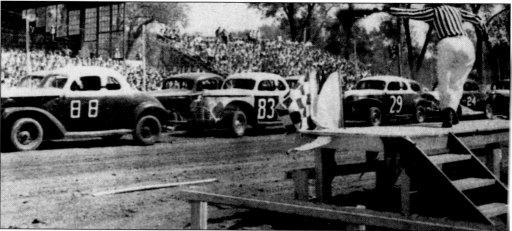

In 1948, Abraham and Louis Slusky opened Playland Park at 4040 West Broadway with 25 amusement rides on 60 acres, including the signature three-block-long roller-coaster that carried thrill seekers over two city streets. The Slusky brothers subleased Lansky's Kennel Club track, which evolved into the Playland Speedway. Construction of the Interstate 480 bridge brought an end to the wooden coaster in 1964, and in 1966, Playland Park consisted of the speedway and a dozen rides, including the Wild Mouse coaster. After Abraham's death in 1970, the amusement rides were moved to Frontier City in Oklahoma, but stock car races continued at the speedway until the last race in 1977.

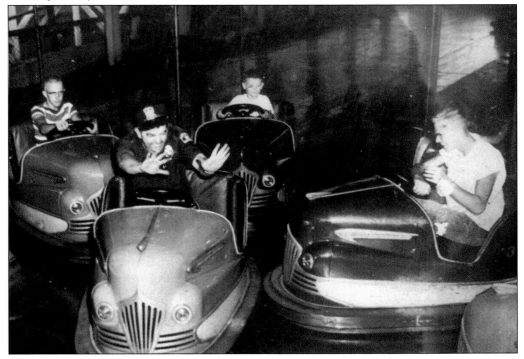

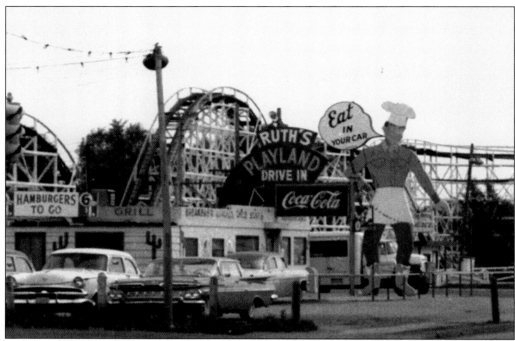

Two October 1959 views of West Broadway with the entrance to Playland Park at West Broadway and Fortieth Street are shown here. The picture below shows West Broadway east of Fortieth Street with hamburgers to go at Ruth's Playland Drive-In and Nathan P. Dodge Memorial Park across the street. The park was established in 1914 on 139 acres donated to the city by Maj. Gen. Grenville Dodge and gambler Benjamin Marks and became an 18-hole municipal golf course in 1927. Oddly enough, while Dodge was busy building the Union Pacific west through Wyoming, Marks opened his Dollar Store in Cheyenne that David Maurer later credited as originating the "backbone of all big-time confidence games." (Courtesy of Lt. Robert L. Miller.)

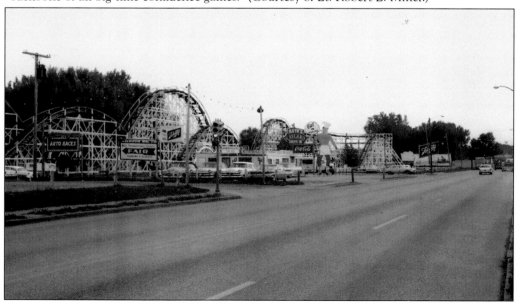

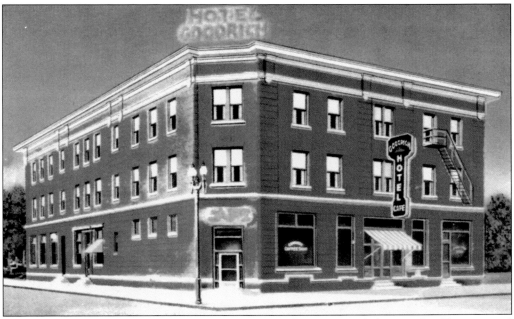

Walt Goodrich spent 16 years working for the Northwestern and then at the Tremont and Metropolitan hotels before opening the Goodrich Hotel at 801 West Broadway in 1906. The Goodrich featured "all modern conveniences" with a bar and café and rates from $1.25 to $2 daily. A 1922 fire resulted in one death, but the Goodrich remained open until 1984 when the last hotel in downtown Council Bluffs closed.

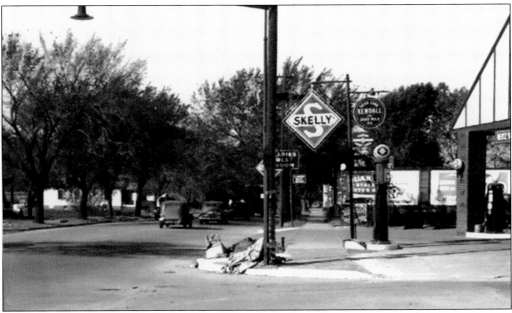

The Metz Super Service Skelly Station at West Broadway and Twenty-seventh Street is seen in October 1947. Byron Reitz operated the station for 53 years. (Courtesy of Lt. Robert L. Miller.)

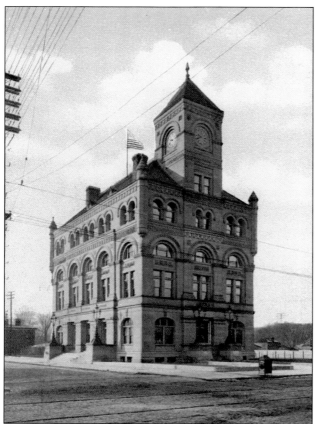

The Council Bluffs Post Office and federal building on the south side of West Broadway at Sixth Street was demolished in 1952. The present Council Bluffs Post Office was erected in the same location by 1958. In the meantime, the General Dodge Council Bluffs Station was open inside the city auditorium on Bryant Street.

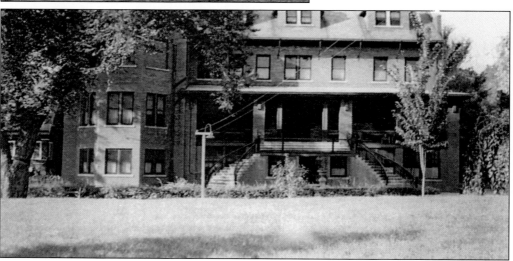

The all-girl Mount Loretto Catholic High School was at North Broadway and Oak Street. One girl educated here was Helen Marie Delaney, an English girl orphaned when the *Titanic* sunk in 1912. She was sent to Council Bluffs on an orphan train, worked at Kresge's, and died in 1982 without marrying and never discovering who her parents actually were. Mount Loretto closed after St. Albert's High School was established in 1964. (Courtesy of Alice Bontz.)

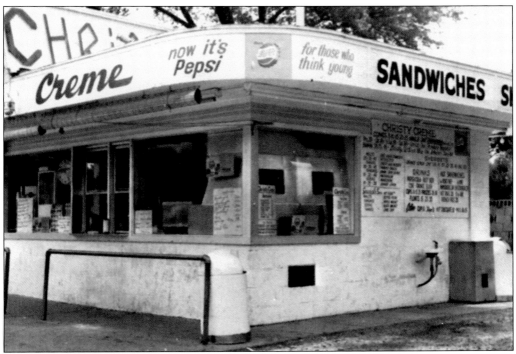

Christy Creme found its niche at 2853 North Broadway after 1954 when Art Christiansen put up the original building in his front yard for a little extra income and to give his wife, Jeanne, something to do while their children were at school. The business still survives today, housed in a much larger building and is now operated by Art and Jeanne's son Dave.

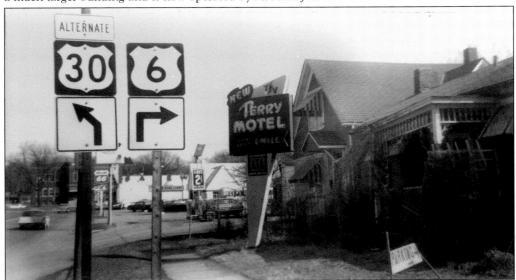

This advertisement at 823 East Broadway was for the Terry Motel at 2724 North Broadway. The signs gave travelers the transcontinental choice of hanging a left up North Broadway to take Highway 30 to New York City or taking a right to reach Provincetown, Massachusetts, via Highway 6, America's longest cross-country highway. (Courtesy of the Council Bluffs Public Library.)

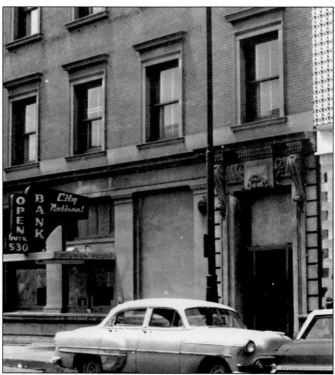

The City National Bank Building at 500 West Broadway is seen in the 1950s.

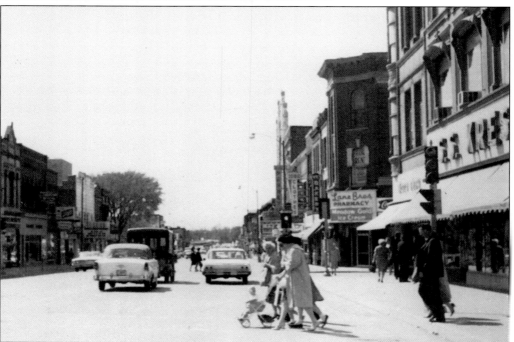

Pedestrians cross busy West Broadway in front of S. S. Kresge's in the Wickham Building at 516 West Broadway.

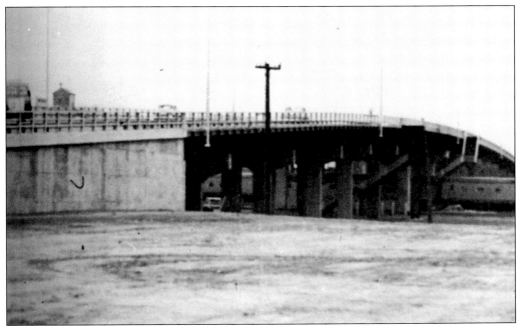

A Northwestern passenger train rolls underneath the new Broadway viaduct, which was completed in 1955 over the tracks between Eighth and Fifteenth Streets. The last Northwestern steam-powered engine rolled out of Council Bluffs in June 1953, and passenger service on the line ended altogether in 1960.

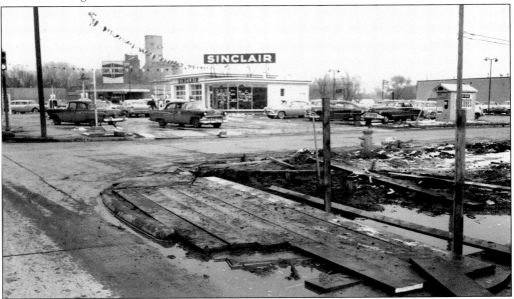

Tires are on sale at the Sinclair at West Broadway and Thirty-fifth Street in April 1957 with two of the city's many iconic grain elevators looming in the background. This photograph was taken by Council Bluffs police sergeant C. E. "Pat" Moore, who was killed during a 1961 shoot-out on Fifth Avenue after he chased down the robbers of the First National Bank branch at West Broadway and Twenty-ninth Street. (Courtesy of Lt. Robert L. Miller.)

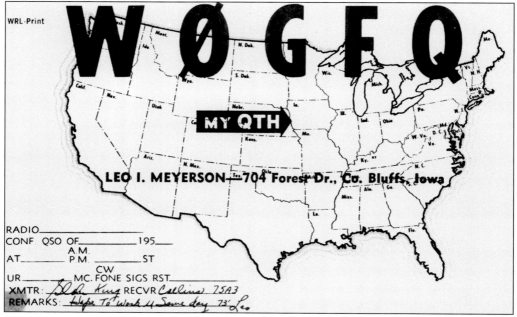

Leo Meyerson was eight when his family moved to Council Bluffs where his father worked at People's Department Store. Meyerson left college and borrowed $1,000 from his father to open a radio parts store at 742 West Broadway where he repaired and resold radios solicited through the mail as Wholesale Radio Laboratories. The business received a tremendous boost during World War II with contracts to mass-produce radio crystals. Afterward World Radio's Globe Electronics produced the Scout and Globe King transmitters. In 1958, the company moved its manufacturing, local sales, and mail-order operations into a new building at 3415 West Broadway constructed on the former American Legion ballpark where the Omaha Cardinals once played. World Radio's massive antennas dominated West Broadway, and every electronic part or component known was available. With Meyerson's son Larry as president, World Radio expanded into home electronics with 24 retail outlets in four states during the 1980s.

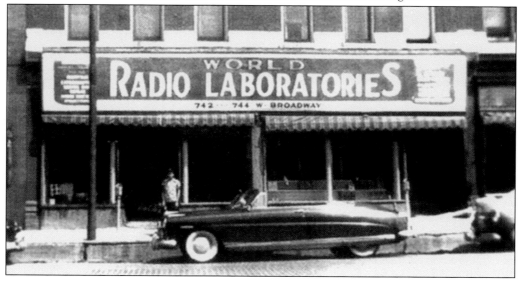

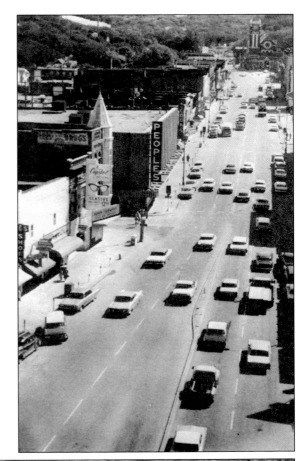

Two views of West Broadway in the 1950s and 1960s show the Sanborn Block and a busy day at People's Department Store at 308 West Broadway. The merchants who made up People's included the five Krasne brothers, Herman and Sam Meyerson ran the grocery department, and Louis and Morris Baumstein took care of the hardware section.

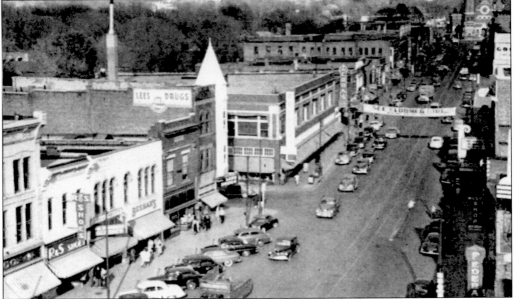

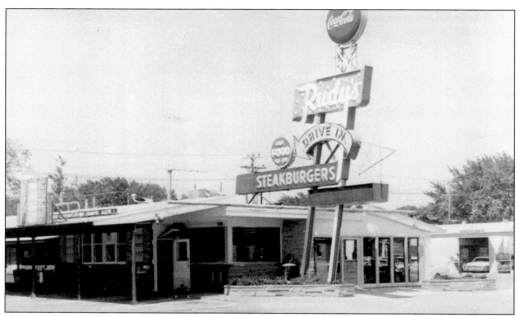

It was hard to miss the sign advertising steakburgers and Coca-Cola at Rudy's Drive-In at 1902 West Broadway. During the late 1960s, Rudy's became D. J.'s Drive-In and continued in business into the 1970s.

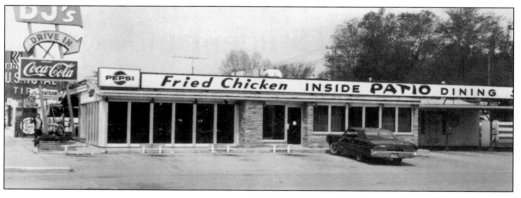

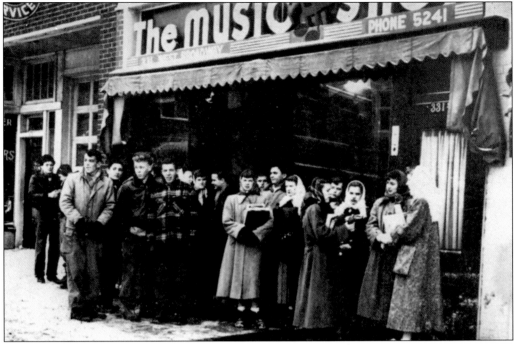
Teenagers lined up in front of the Music Shop at 331 West Broadway.

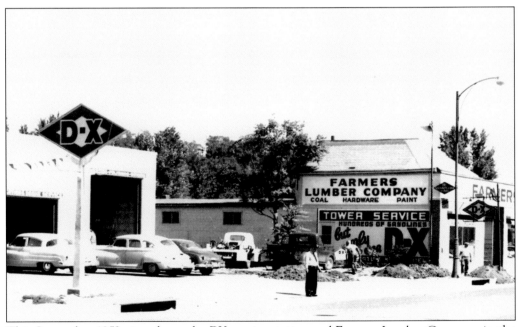
This September 1953 view shows the DX service station and Farmers Lumber Company in the 300 block of East Broadway. Farmers Lumber operated here from 1915 until the business closed in early 1991. (Courtesy of Lt. Robert L. Miller.)

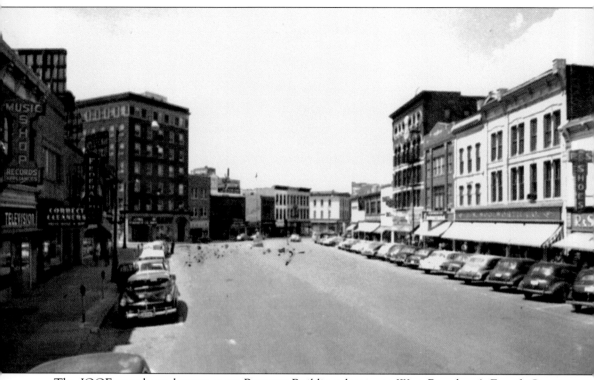

The IOOF temple and seven-story Bennett Building dominate West Broadway's Fourth Street angle during the 1950s. In May 1937, Walgreen Drug held its grand opening in the IOOF temple, and the new store included a 75-foot-long counter at the soda fountain. The Bennett Building was constructed in 1924 on the site of the Keller and Bennett Block and was named after businessman and local politician John Bennett. It was placed on the National Register of Historic Places in 2001.

The entrance to Iowa and Council Bluffs is seen at Forty-first Street and West Broadway in the early 1960s. (Courtesy of the Council Bluffs Public Library.)

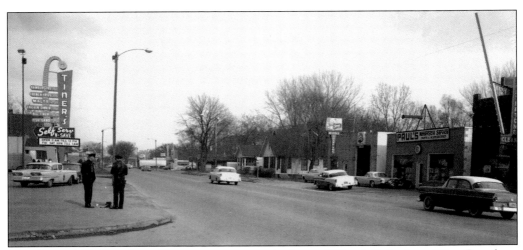

Two Council Bluffs police officers compare notes in front of Tiner's Drive-In at West Broadway and Thirty-fourth Street in 1962. Across the street are the cabins of the Mandarin Court Motel, Falstaff and Storz beer advertised by McCarl's Drive-Inn, and Paul's Motorcycle. (Courtesy of Lt. Robert L. Miller)

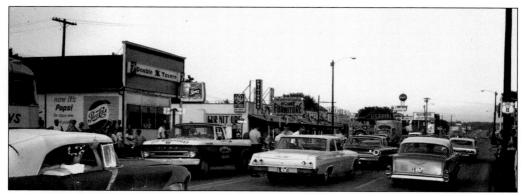

People are cruising in curlers near West Broadway and Twentieth Street in July 1965. The Storz beer advertised by the Double X Tavern was brewed in Omaha from 1876 to 1972. (Courtesy of Lt. Robert L. Miller)

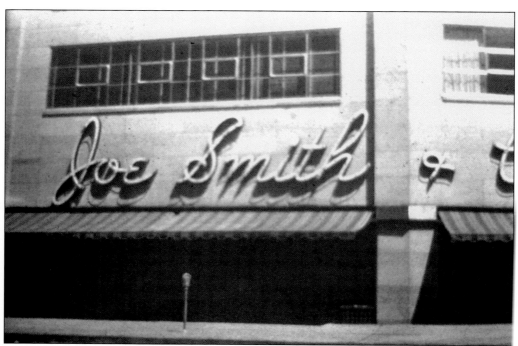

Joe Smith and Company at 412–416 West Broadway was unique in reflecting West Broadway's Fourth Street angle in its curving facade. After 73 years in business, Joe Smith and Company closed in 1972 as part of the urban renewal of downtown. (Courtesy of Robert Warner Sr.)

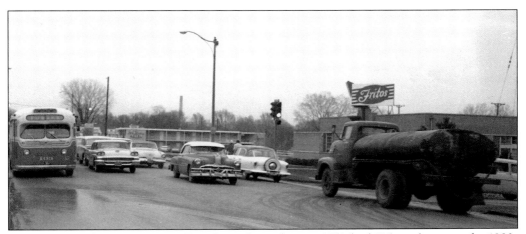

The Frito-Lay plant at 3919 West Broadway, shown here in 1959, had 125 employees in the 1980s where it produced its popular brand of corn and tortilla chips. Frito-Lay's Council Bluffs plant was closed in 2004 and has since been razed. (Courtesy of Lt. Robert L. Miller.)

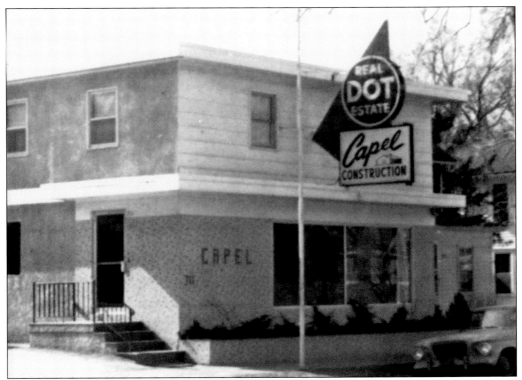

DOT Real Estate and Capel Construction are seen at East Broadway and Frank Street. (Courtesy of the Council Bluffs Public Library.)

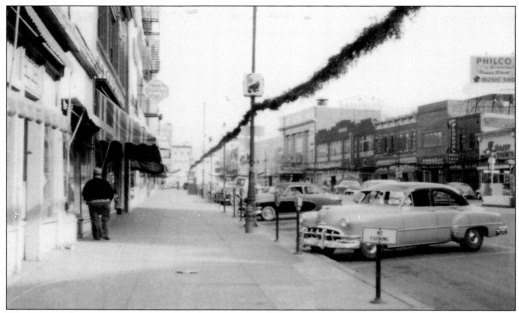

Christmas decorations and parking meters line the 300 block of West Broadway in the 1950s. Vandals damaged 29 of the new meters on West Broadway between Scott and Eighth Streets before they took effect on April Fools Day in 1948. Two hours of parking cost a dime, and Lloyd Mischler was issued the city's first ticket for not plugging the meters.

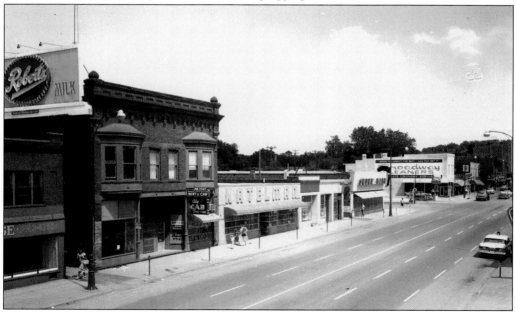

City Cab, Katelman Hardware, and the Super Value Supermarket are seen on the north side of the 700 block of West Broadway in August 1959. Some of the businesses along this stretch of West Broadway in 1918 included Karl Brandeis grocery, the Eagle Steam Laundry, the Fisk Rubber Company, Hammill College, Harding Ice Cream, and the Lincoln Highway Tire and Rubber Works. (Courtesy of Lt. Robert L. Miller.)

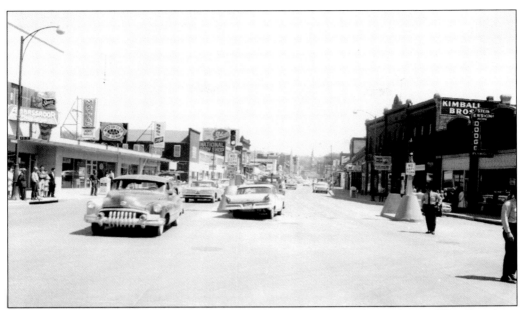

There really was no left turn for this 1957 Ford that smashed into the median at West Broadway and Eighth Street in April 1960 as a crowd gathered outside the Ambassador Lounge to gawk. (Courtesy of Lt. Robert L. Miller.)

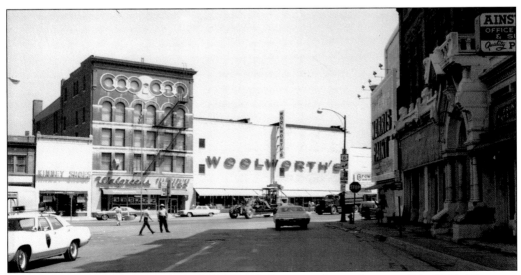

Woolworth's and other businesses of the Fourth Street angle are shown in July 1970. (Courtesy of Lt. Robert L. Miller.)

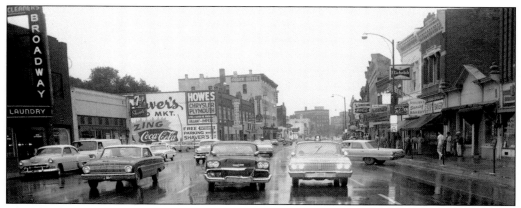

The aftermath of a fender-bender involving a 1958 Chevrolet in the 100 block of West Broadway is seen on a rainy July day in 1963. (Courtesy of Lt. Robert L. Miller.)

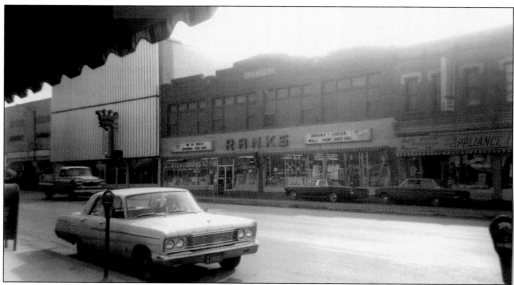

King's Food Host was located at 317 West Broadway, and Ranks Department Store was in the Madsen Building at 325–329 West Broadway. The Broadway Theatre closed in 1959 and was remodeled into King's, a restaurant chain based in Lincoln, Nebraska, known for its tuna and cheese "frenchies" and system of placing orders via a telephone installed in each booth. (Courtesy of the Council Bluffs Public Library.)

The view north on Pearl Street shows Beno's Department Store at 508–514 West Broadway and the Council Bluffs Savings Bank across the street.

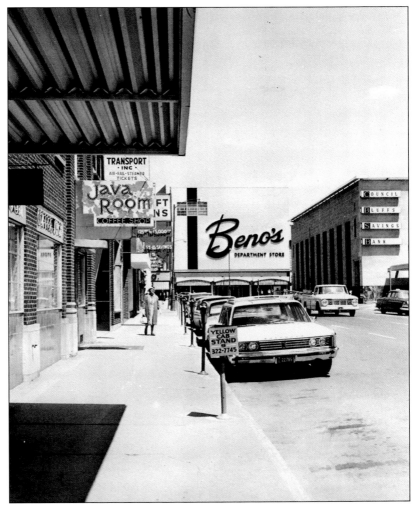

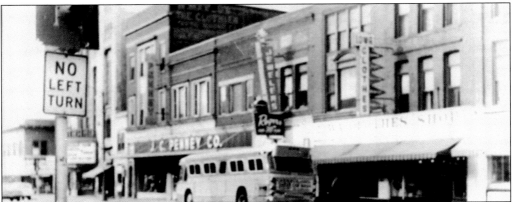

J. C. Penney, Rogers Jewelry, and Iowa Clothes are on the north side of the 500 block of West Broadway. The building that houses J. C. Penney was where M. F. Rohrer took his oath of office to become mayor of Council Bluffs in 1887.

Two views of West Broadway east of the Fourth Street angle in the 1960s show such landmarks as the IOOF temple, Danish Hall, the Ogden House Hotel, and the Broadway Methodist Church on the corner of First Street.

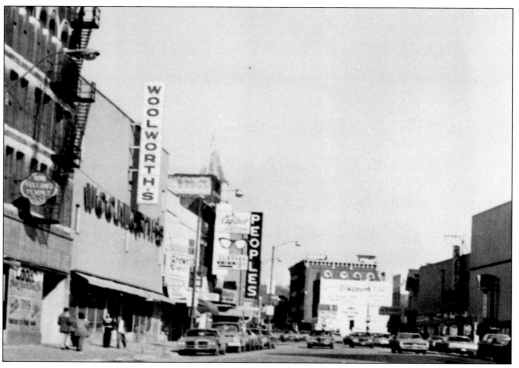

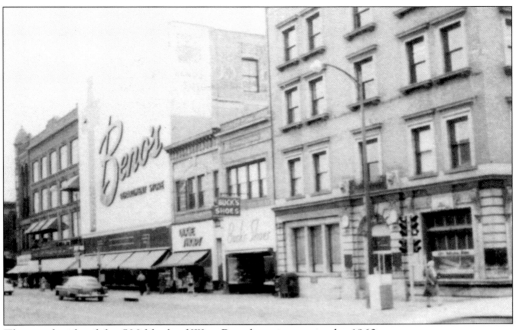

The north side of the 500 block of West Broadway is seen in the 1960s.

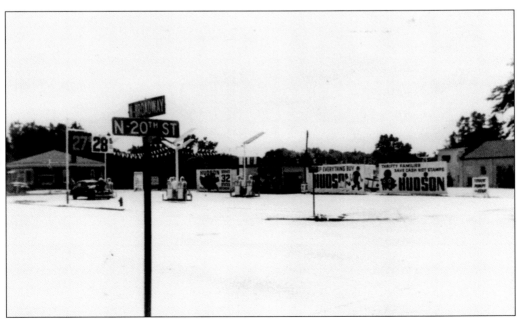

The Hudson Service Station at West Broadway and Twentieth Street is shown in 1962. (Courtesy of the Council Bluffs Public Library.)

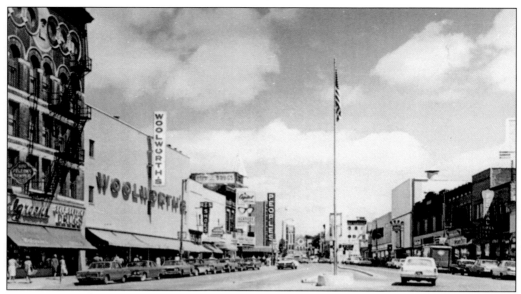

This was how West Broadway looked both west and east of the Fourth Street angle in the 1960s when this stretch of downtown Council Bluffs attracted shoppers from throughout southwest Iowa.

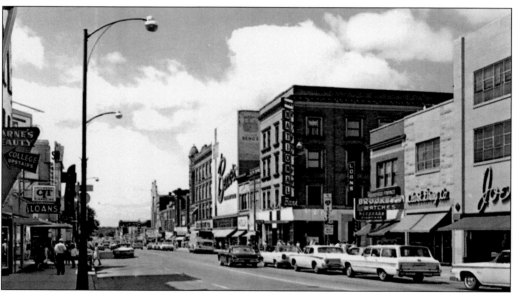

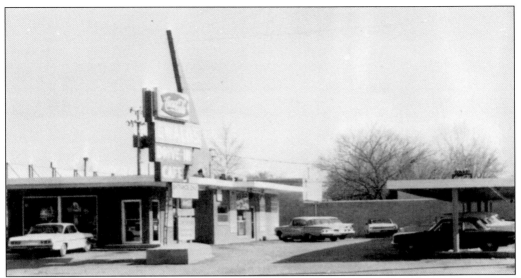

Ewald's Drive-In is shown at Fifteenth Street and West Broadway. Joe Ewald started the D&E Drive-in at 1621 West Broadway before opening Ewald's in 1957. During the 1960s this was the eastern turnaround for teenagers who cruised from West Broadway out to Seventy-sixth and Dodge Streets in Omaha. Ewald sold the business to Ray Howell in 1968, Terry Howell took over in the 1980s, and the building was razed in 2005.

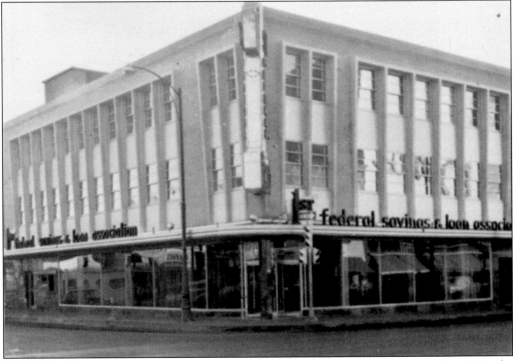

First Federal Savings and Loan opened at 421 West Broadway in 1968. In December 1982, the First Federal branch at 3201 West Broadway exploded during a natural gas leak, killing two men, damaging nearby buildings, and covering the street with broken glass.

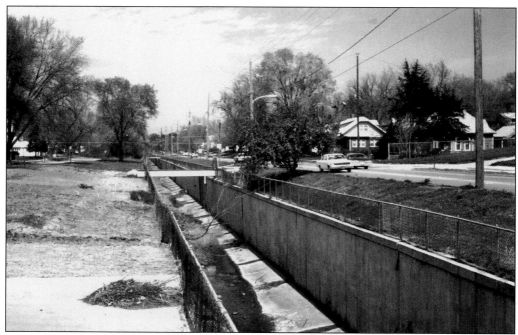

This view is of Indian Creek corralled into a concrete ditch in the 1200 block of North Broadway. Over $1.5 million in federal funds was spent in 1934 to end the flooding that plagued downtown, but the troublesome creek flooded the city west of Seventh Street all the same in 1943 and 1944. To this day, the occasional automobile plunges to the bottom of the Indian Creek ditch. (Courtesy of Robert Warner Sr.)

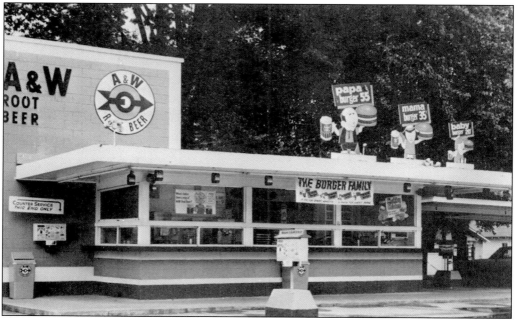

The burger family took a prominent place on top of the A&W Root Beer Stand at 2112 West Broadway.

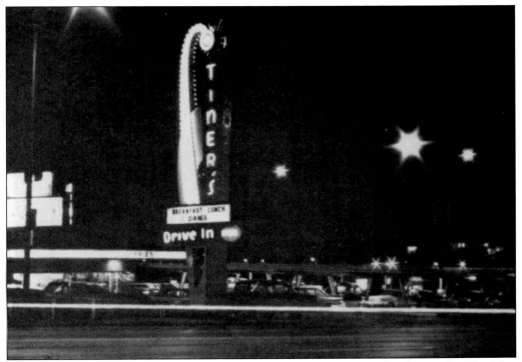

Tiner's Drive-In at 3340 West Broadway was home of the Big Tiner hamburger for 50¢. This became Cosmo's Drive-In in the mid-1960s and continued under that name into the next decade.

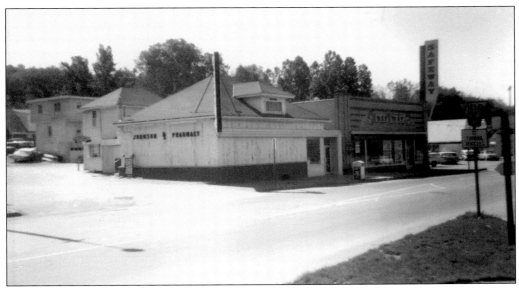

The Johnson Pharmacy at 915 East Broadway and adjacent Safeway Supermarket are shown in September 1965. (Courtesy of the Council Bluffs Public Library.)

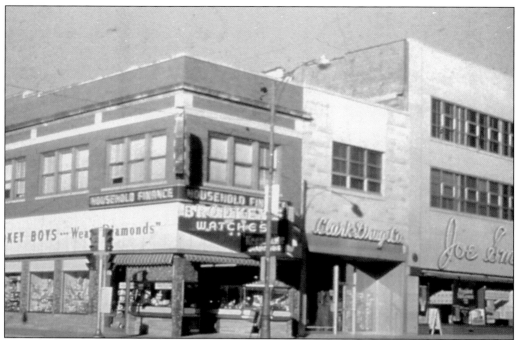

Brodkey's Jewelry, Clark Drug Company, and Joe Smith and Company are seen on the northeast corner of West Broadway and Main Street.

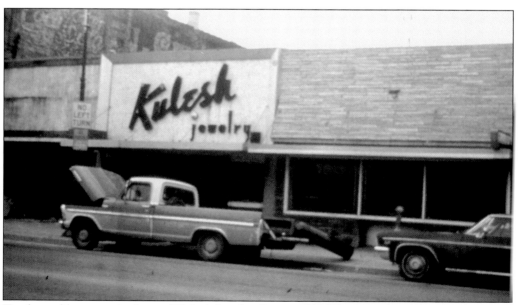

Truck troubles occur in front of Kulesh Jewelry Store at 230 West Broadway. During the 1930s Kulesh advertised itself as "the store of quality" that offered "expert watch and jewelry repairing since 1911." The business was long owned by Ben and Carolyn Cohen and was razed during the early 1970s. (Courtesy of Robert Warner Sr.)

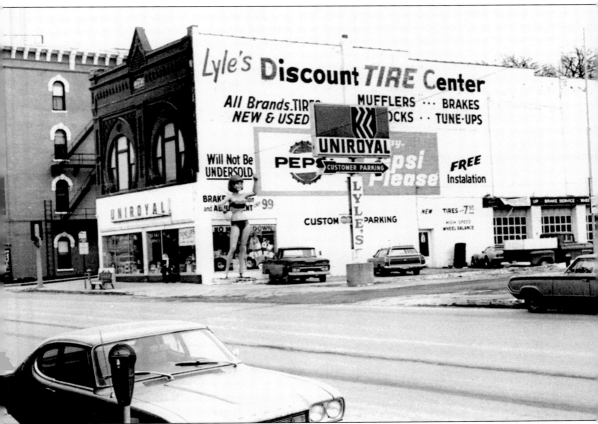

The Hughes Block at 201 West Broadway became Danish Hall in 1900 and the new home for the Danish Brotherhood, Danebo, and Danish Social Society and associated auxiliaries. At the time there were almost 5,000 Danish immigrants and their descendents in town. The Danish Brotherhood was originally composed of veterans of the wars over Schleswig-Holstein, while the Danebo, organized in Council Bluffs in 1878, required that all meetings be conducted solely in Danish. The photograph also shows "Suzibelle," which inspired a long-running court battle between city officials and Lyle's Discount Tires until 1991 when Judge Heath decided that she did not violate any city ordinance but was "more or less a work of art." (Courtesy of the Council Bluffs Public Library.)

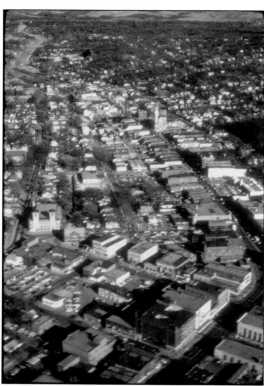

This aerial view of West Broadway, taken during the 1960s, shows the distinctive Fourth Street angle created by Col. Sam Bayliss back in 1853.

A handful of residences can be seen in this March 1959 view of West Broadway and Thirty-sixth Street alongside the towering aerial antennas of World Radio at 3415 West Broadway. (Courtesy of Lt. Robert L. Miller.)

Four

URBAN RENEWAL AND AFTER

The population of Council Bluffs reached its 20th-century peak of just over 60,000 people in 1970 as the city's efforts at urban renewal transformed Broadway forever. More changes came in the 1980s with construction of the Kanesville Boulevard U.S. Highway 6 bypass from Interstate 80. At the same time the Milwaukee, Wabash, and Rock Island Railroads had all disappeared by 1990 when the city's population had declined to just over 54,300. The Northwestern Railroad was then merged into the Union Pacific, the Illinois Central became part of the Canadian National, and in 1994, Council Bluffs passed an ordinance that prohibited the same vehicle driving past a check-point three or more times during a two-hour period between 8:00 p.m. and 5:00 a.m. on Broadway between Thirty-sixth and Frank Streets.

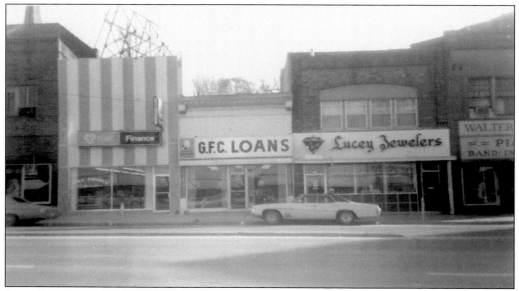

Lucey Jewelers at 329 West Broadway was opened by World War I veteran John Lucey in 1946. After urban renewal he moved into the First Federal Building and was killed during an August 1975 robbery. Almost $140,000 worth of jewelry was soon recovered, and Joe Nuzum and Joachim and Marsha Fuhrmann were all sentenced to life in prison for the robbery and murder. (Courtesy of the Council Bluffs Public Library.)

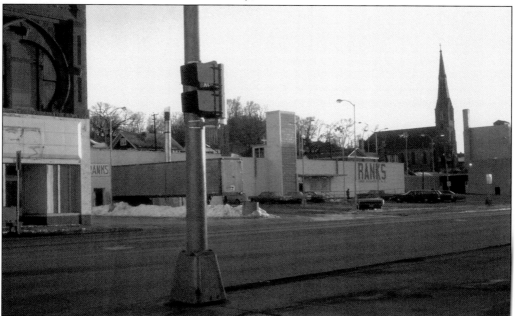

Ranks Department Store is seen at 211–213 West Broadway. This was the last remnant of Woodward's candy factory, and the parking lot on the roof was once rumored to be a potential helicopter landing pad. Formerly Hinky Dinky Supermarket, Ranks Department Store took over after a December 1970 fire destroyed the Madsen Building at 325 West Broadway. (Courtesy of Dr. Robert Warner Jr.)

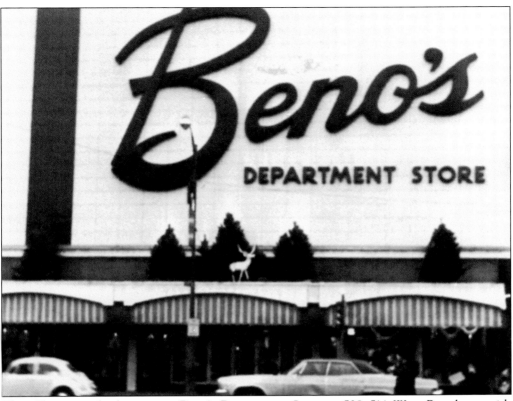

This Christmas display was at Beno's Department Store at 508–514 West Broadway, with additional parking for a price in the alley out back. The modern facade was added to the front of the 1889 Eiseman Block in 1959, and the longtime retail anchor of downtown Council Bluffs closed for good in 1987. (Below, courtesy of Dr. Robert Warner Jr.)

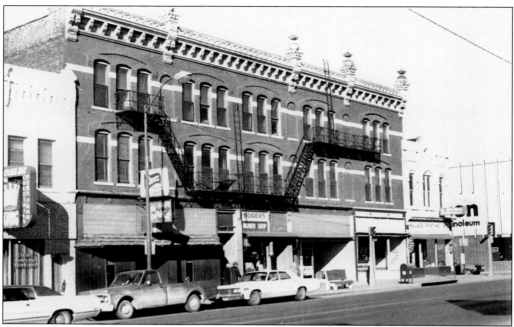

The Club 212-Pizza King and the Bluffs Hotel in the 200 block of West Broadway are seen in the early 1970s. After urban renewal, the Pizza King reopened in its present location at 1101 North Broadway. (Courtesy of the Council Bluffs Public Library.)

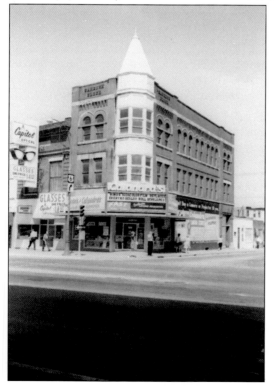

Calandra Cameras was the final tenant in the Sanborn Block at 326 West Broadway. The Sanborn was designed by architect Charles Bell and was razed during the urban renewal of downtown Council Bluffs. (Courtesy of the Council Bluffs Public Library.)

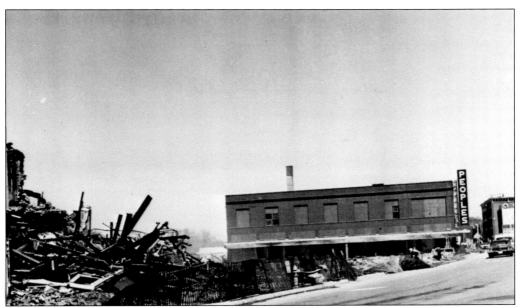

The suburban sprawl of the 1960s brought death to downtowns across the nation. In an attempt to avert this, the city embarked on an ambitious (and still controversial) plan to revitalize downtown with a comprehensive urban renewal project. The city first applied for a grant from the Department of Housing and Urban Development in December 1966 that would totally transform the 38.1-acre urban renewal area over the next decade. The rubble shown above was once the Sanborn Block. People's Department Store was demolished in April 1973, as shown below, while King's and the Continental-Keller Furniture building across the street await the wrecking ball.

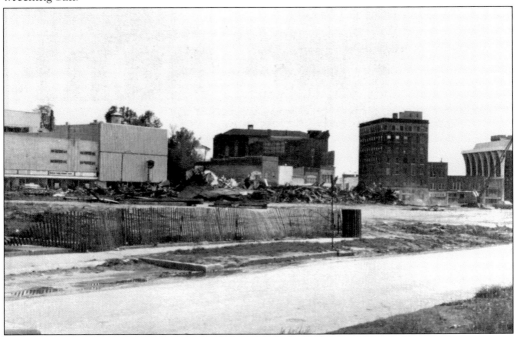

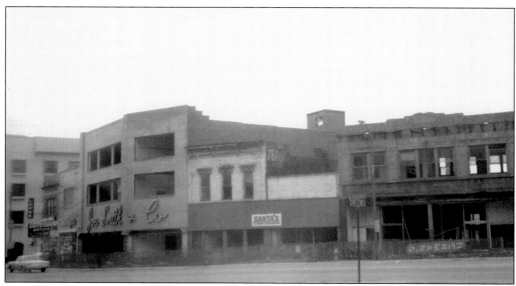

A final look at the 300 block of West Broadway is seen as demolition begins in the spring of 1973. (Courtesy of Robert Warner Sr.)

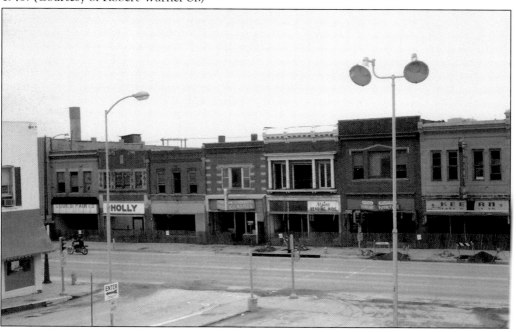

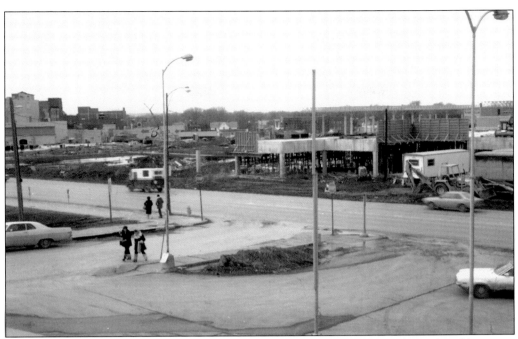

The aged buildings and inadequate parking along West Broadway were to be replaced by a new and modern shopping mall, complete with an enclosed parking garage. These two views show the construction of Midlands Mall during the mid-1970s. (Courtesy of Robert Warner Sr.)

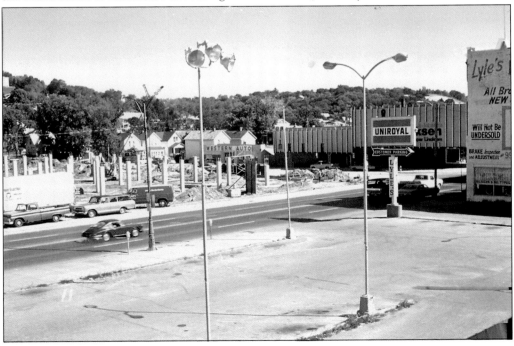

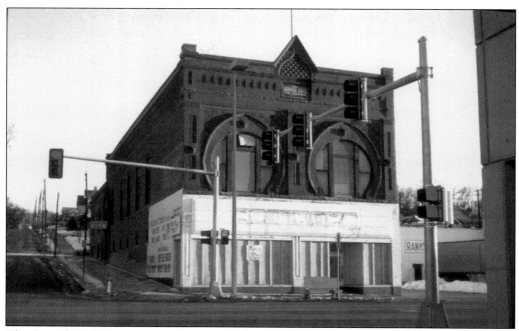

The Danish Hall is seen in its last days before urban renewal. The view below looks north from Fourth Street at the old Broadway Theatre at 317 West Broadway. (Courtesy of Robert Warner Sr.)

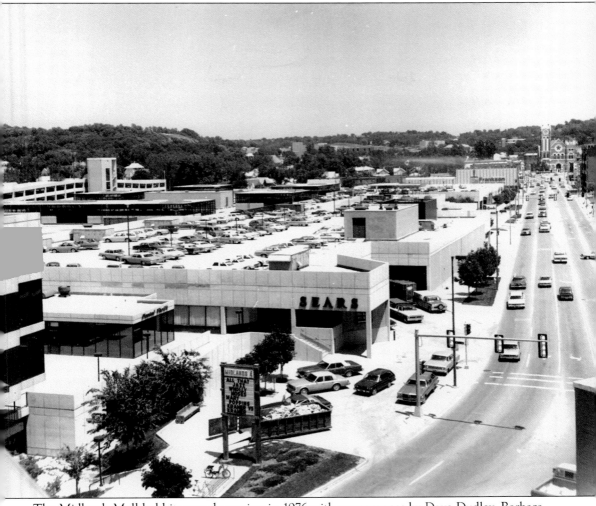

The Midlands Mall held its grand opening in 1976 with appearances by Dave Dudley, Barbara Fairchild, and Bob Everhart. The $35 million facility's main anchor stores included Sears, Phillips, and Brandeis, which had the city's first escalator. The mall was put up for sale in 1987, renamed the Centre Point Mall in 1988, and closed after voters rejected bond issues in 1989 and 1991 to transform the shopping center into an additional campus for Iowa Western Community College. After a period of abandonment and vandalism, Midlands Mall reopened as the Omni Business Park. This 1979 photograph was taken by R. H. Fanders, who taught drama to a few generations at Thomas Jefferson High School at 2501 West Broadway. (Courtesy of the Council Bluffs Public Library.)

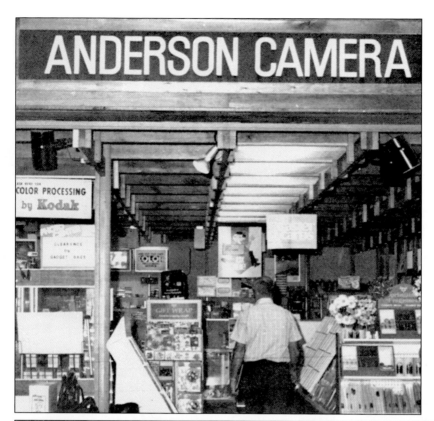

The food court and Anderson Camera are seen inside the Midlands Mall.

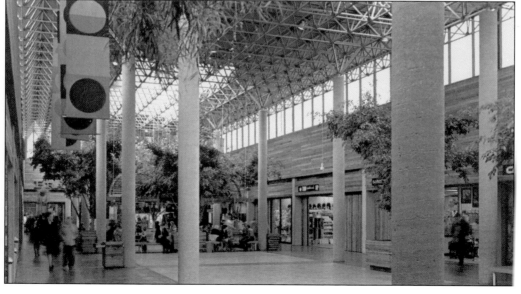

Pogge Heating and Air Conditioning and other businesses are shown on East Broadway in the 1970s. (Courtesy of the Council Bluffs Public Library.)

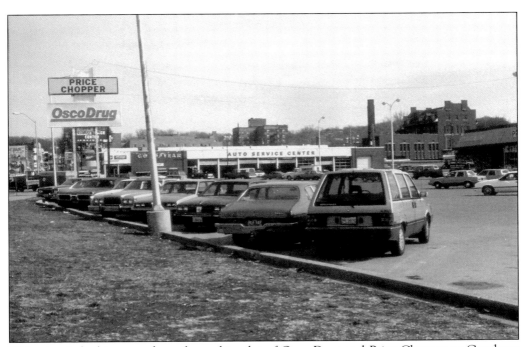

This view is looking east from the parking lot of Osco Drug and Price-Chopper at Goodyear Tire and Rubber at 715 West Broadway in the early 1980s with the Bennett Building at West Broadway and Fourth Street and the Railroad YMCA on First Avenue in the distance.

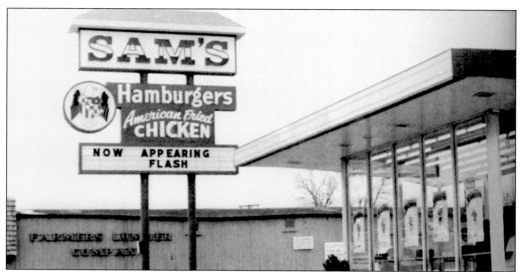

Sam's Hamburgers at 410 East Broadway was located in what had been a Bronco's Burgers and is presently the home of Burgers on Broadway.

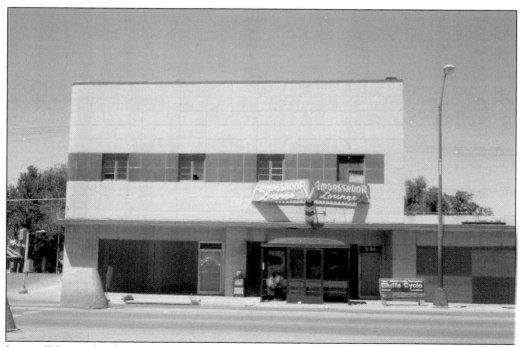

Last call looms for the Ambassador Lounge at 740 West Broadway shortly before the building was demolished. The building had once housed the Blue Ribbon Casino, Abraham Diamond's deli, and the Iowa Furniture Store.

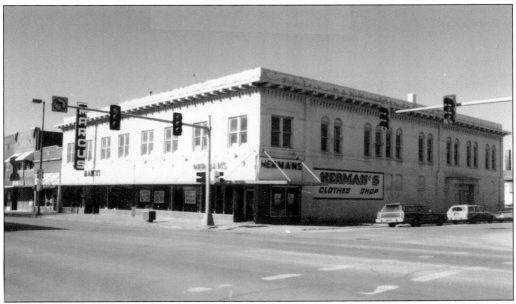

Herman's Clothes is seen on the northwest corner of West Broadway and Sixth Street before the Kanesville Boulevard bypass. Martin Lee's Cigar Factory, Safeway Grocery, and the Sixth Street Market had all been located here, and this was where the Danish-language newspaper *Folke-Badet Dannebrog* was briefly published in the 1890s. (Courtesy of the Council Bluffs Public Library.)

Rog and Scotty's, Katelman Hardware, Scotty's Furniture, and Berry Brothers Music were in the 700 block of West Broadway. In business since 1934, Louis and Rose Katelman had relocated here after a 1950 fire. After Louis died in 1963, Rose continued the business, which gained the reputation as the place to find any and every hardware obscurity known until 1981 when it closed as part of the Kanesville Boulevard bypass. (Courtesy of Dr. Robert Warner Jr.)

Here are the Foxy Lady and Night Moves Lounge at 630 West Broadway shortly before the block was demolished as part of the Kanesville Boulevard bypass. The building had formerly housed Broadway Cleaners and Mariano Dinovo's shoe repair. (Courtesy of the Council Bluffs Public Library.)

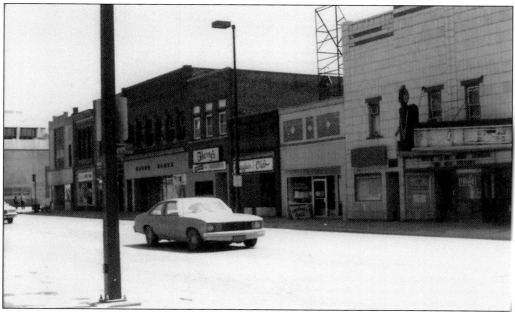

In 1984, the city council voted to raze the 500 block on the south side of West Broadway including the much-maligned Crest Adult Art Theater at 547 West Broadway. The Crest opened in 1969 in the former Liberty Theater and closed for good in 1985. The lone holdout was attorney Donald Baird who refused to vacate his offices at 537 West Broadway until February 1986. (Courtesy of Gary Emenitove.)

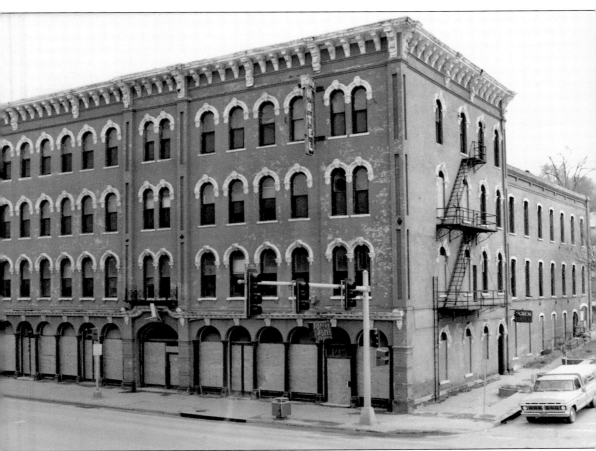

The Ogden Hotel at 173 West Broadway was listed on the National Register of Historic Places in 1976, closed its doors in 1977, and was demolished in the early 1980s. In the late 19th century, the Ogden boasted itself as "elegantly furnished, with elevators, electric bells in each room, large sample room for commercial men, careful and painstaking attendants, and everything required for comfort and convenience." In 1975, when rates were still only $3 a night, the Ogden manager Will Smith admitted that "It's hard to say this about your own establishment, but this about the last stop for most of the people here."

In the summer of 1980, a transformation took place in the otherwise nondescript Hill Apartments at 3600 West Broadway that effected the Omaha radio market for the next two decades. KQKQ-FM dropped its heavy metal format and replaced over 95 percent of its staff. The station became Sweet 98 and was well known for its outlandish promotional stunts. Mark Evans was brought in from Kentucky and paired with KQKQ disc jockey Dick Warner (above) to become the morning team of "Mark and Dick the Breakfast Flakes." To cultivate a more metropolitan image, business offices were set up across the river and only the Omaha address publicized. The station's ratings soared, but few listeners realized that the actual programming came from the disheveled and unlabeled West Broadway apartment building with a curious array of antennas the only indication of what was taking place inside. Licensing rules were eventually relaxed, and the studios moved to a far more opulent Omaha facility at Tenth and Farnam Streets.

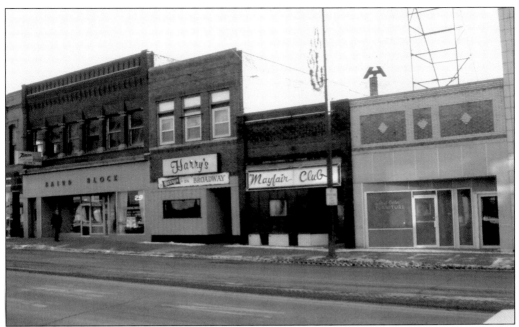

The Baird Block, Harry's on Broadway, and the Mayfair Club were on the south side of West Broadway west of Pearl Street. A December 1944 raid on the Mayfair Club found an illegal horse-betting parlor in the basement and resulted in 57 arrests. Sixty people were arrested after an October 1946 raid on the Empire Buffet at 541 West Broadway, and the Mayfair was raided again in 1948 for illegal gambling. (Courtesy of Barb Warner.)

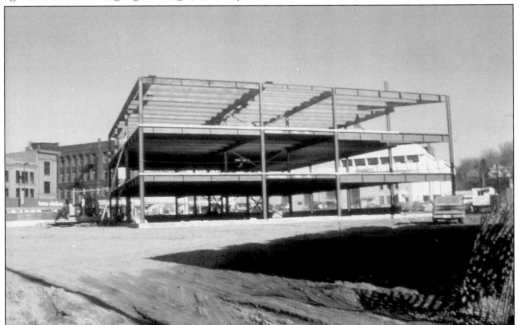

Construction of the Redlands Insurance Building is shown in the 500 block of West Broadway in 1986. The building currently houses Heartland Properties and the offices of the *Daily Nonpareil*.

This historical mural was on the west side of the Hite Center at 540 West Broadway. The building had been the longtime home of J. C. Penney and was awaiting redevelopment when it was devastated by fire in August 1989. Three teenagers were later charged over the incident. During demolition, a backstage view was revealed of the old Majestic Theater that had once operated here. Several theaters were once clustered near the Majestic and the Dohany at adjacent 554–556 West Broadway. Those listed in one 1910 city directory included the Bijou at 545, the Elite at 541, the Diamond at 520, and the Star Theater at 502 West Broadway. (Courtesy of Barb Warner.)

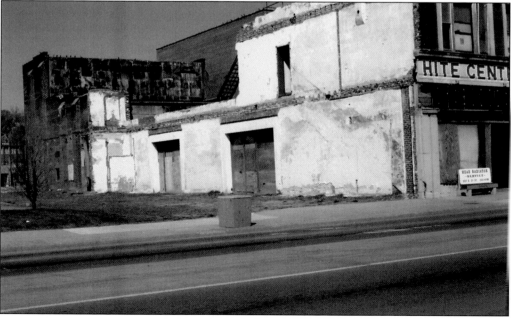

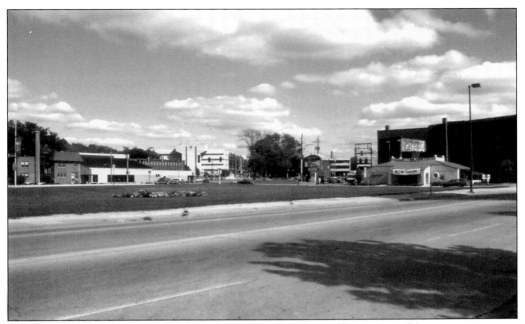

The 700 block of West Broadway is seen after the Kanesville Boulevard bypass project was completed to route traffic from the U.S. 6 exit of Interstate 80 off of West Broadway through downtown. (Courtesy of Barb Warner.)

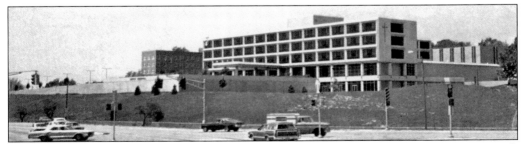

Mercy Hospital and the statue of the Virgin Mary overlook the intersections of East and North Broadway with Kanesville Boulevard in the 1980s. This was the former location of St. Bernard's until the two hospitals were merged in the late 1960s. The hospital was consolidated into the Mercy Health System of the Midlands in 1985, became part of Bergen-Mercy Health in 1994, and then Alegent Health in 1996.

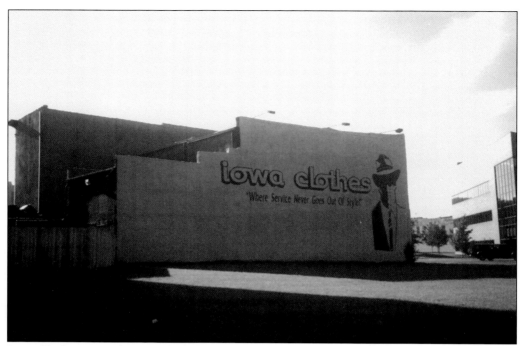

Iowa Clothes was a long-established fixture in downtown Council Bluffs that first opened in 1918 at 536 West Broadway by World War I veteran Harry Cohen, who expanded the store in 1930. Iowa Clothes had the reputation as the place in Council Bluffs for finer men's clothing even after Cohen's 1974 death. After operating for years at 536–538 West Broadway, the business took over the remaining storefronts on the block. Iowa Clothes closed in 1997 and is now the location of Stewart's School of Hair Design. (Courtesy of Barb Warner.)

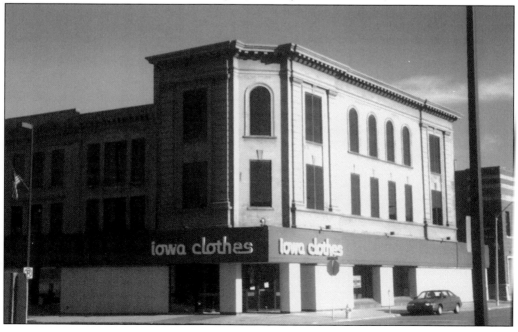

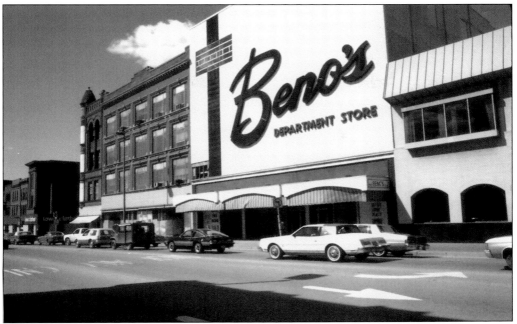

Here is a final look at the Sapp Block, Wickham Block, and Eiseman Building on the north side of West Broadway between Pearl and Scott Streets in the 1990s shortly before these buildings were razed.

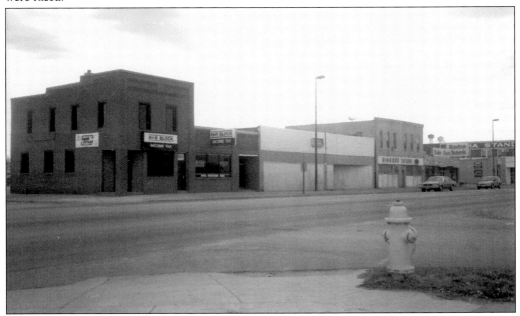

Ginger's Tavern and "Dirty Ernie's" on the south-side of the 2300 block of West Broadway were demolished in the early 1990s to expand operations of Omaha Standard. Businesses here in the 1930s included the medical and dental offices of Doctors Hankey and Saunders, Beaumont Cleaning, Koebel's barbershop, Walkington's Beer and Billiards, and Boyer's Hardware. (Courtesy of Barb Warner.)

This is the last home of the Council Bluffs Savings Bank at 507 West Broadway in the 1990s. This building was demolished and is now Broadway Park. (Courtesy of the Council Bluffs Public Library.)

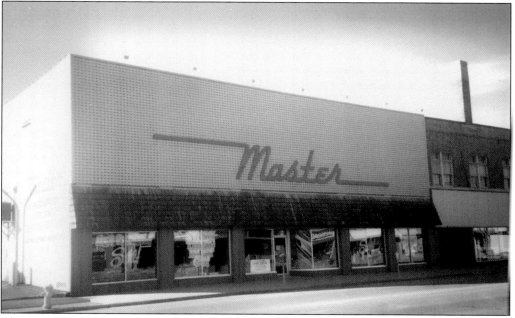

The Suvalsky family operated Master Furniture and Appliance at 149 West Broadway for many years. A longtime model railroad enthusiast, Selwin Suvalsky donated a large portion of his layout to the historical society that is now on display at the Railswest Museum in the 1899 Rock Island and Pacific passenger depot on South Main Street. (Courtesy of Barb Warner.)

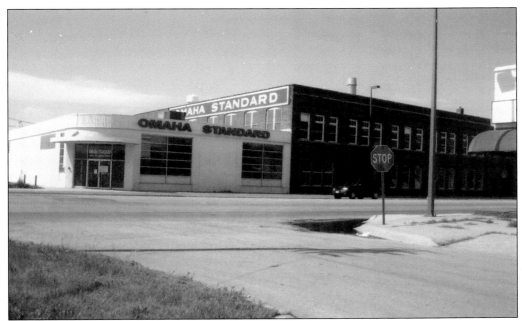

Omaha Standard at 2401 West Broadway was formed after the mid-1920s merger of Omaha Manufacturing with Standard Box, which had produced wagon bodies and shovel boards on West Broadway since 1904. Omaha Standard relocated operations in 2006, and the building was demolished. (Courtesy of Barb Warner.)

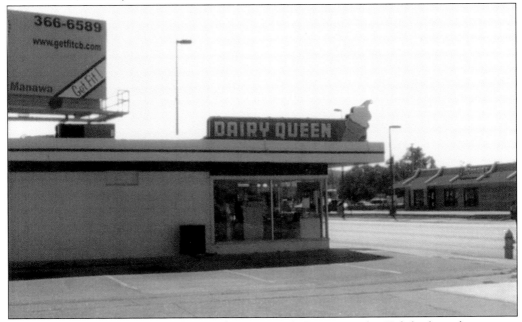

The Dairy Queen at West Broadway and Seventeenth Street was the 10th built in the country when it first opened in 1947 and was the oldest Dairy Queen still operating in its original location until it was razed in 2006. During the 1960s, another Dairy Queen of a similar design was open at 2729 West Broadway. (Courtesy of Barb Warner.)

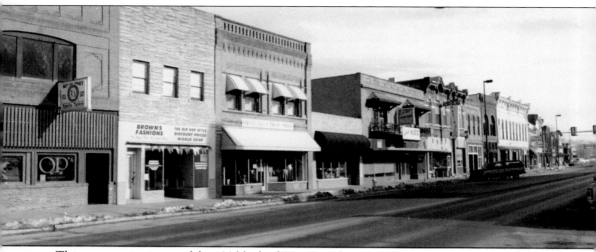

This panoramic view is of the 100 block of West Broadway in 2002, shortly before these buildings were placed on the National Register of Historic Places. The hip-hop style was available at Brown's Fashions at 160 West Broadway with Lidgett Music at 150–152 West Broadway. The Mynster Building at 148 West Broadway was built in 1882, likely by Wilhelm Mynster who had immigrated from Denmark with his parents in 1846 and settled in Kanesville five years later. Mynster graduated from law school in Albany, New York, in 1866 and opened his first law office in Council Bluffs in 1867. Over the years the Mynster Block was home to the Walter Brothers Harness and Saddle, Olson's Barber Shop and Billiards, and Brown's Loans and served as the local campaign headquarters for Democratic candidate John Kerry during the 2004 presidential campaign. The three-story buildings at the eastern end of the block were built during the 1850s by Lysander Babbitt where the U.S. Land Office operated and the *Western Bugle* and *Omaha Arrow* newspapers were published. (Courtesy of Richard Miller.)

Five
PARADES AND PROCESSIONS

Everyone loves a parade, and Broadway has been the site of many. Holidays, both national and local, as well as high school homecomings and funeral processions have brought throngs to the city's main thoroughfare. Many people never think to snap pictures of the street's buildings normally, but everyone brought their camera to a parade. The structures behind the marchers are a time capsule of Council Bluffs business history.

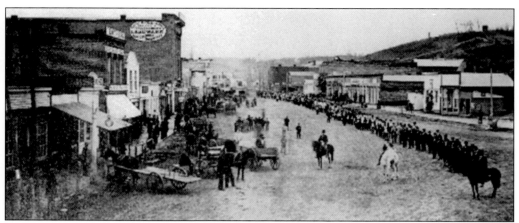

Participants in the IOOF convention at Council Bluffs lined up down West Broadway east of Fourth Street on April 27, 1868.

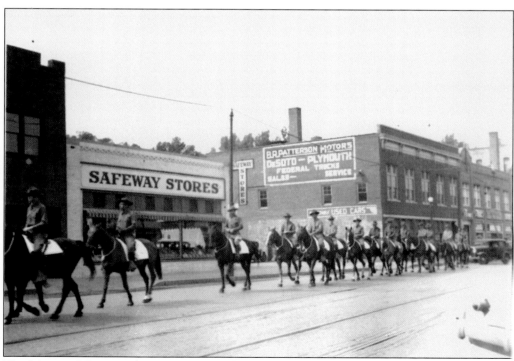

The Memorial Day parade in 1938 passes through the 100 block of Broadway.

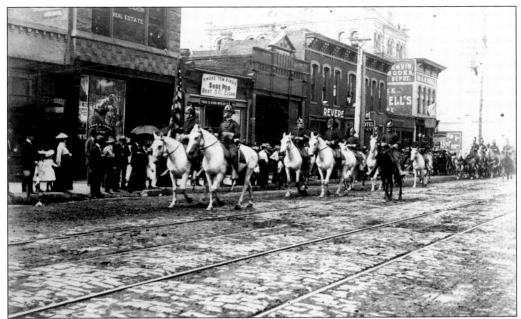

The Buffalo Bill Wild West Show returned to Council Bluffs in 1900 with a parade through the city past the Revere House at 549 West Broadway. The Revere offered 40 sleeping rooms in the 1890s when it was operated by A. Wheeler who came to town from Buffalo, New York. (Courtesy of the Council Bluffs Public Library.)

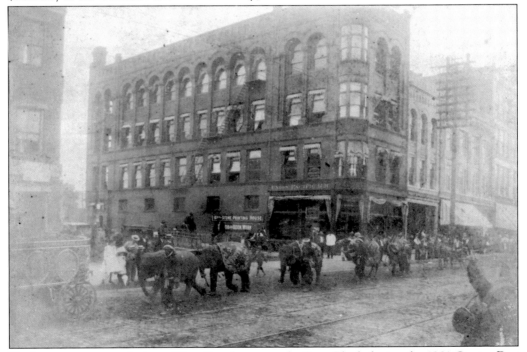

Elephants are on parade down West Broadway past the Sapp Block during the 1901 Gentry Dog and Pony Show. (Courtesy of the Council Bluffs Public Library.)

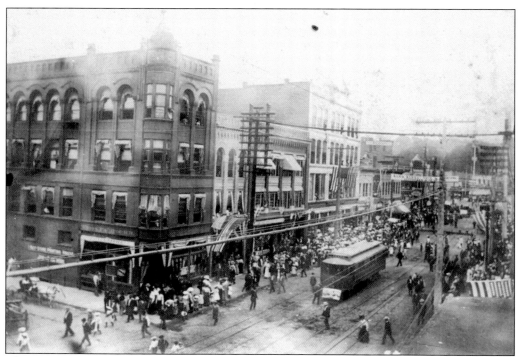

The 1902 Labor Day parade took place on West Broadway. (Courtesy of the Council Bluffs Public Library.)

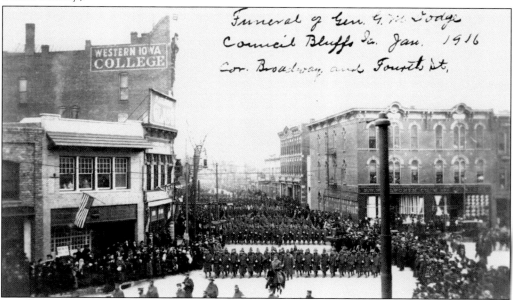

The funeral procession of Maj. Gen. Grenville Dodge makes its way onto West Broadway from Fourth Street in January 1916. At the time of his death, Dodge was the last surviving major general of the Civil War and his Council Bluffs mansion, built the same year he completed construction of the Union Pacific, is now a national historic landmark open to the public. (Courtesy of the Council Bluffs Public Library.)

The spirit of Council Bluffs, during the May 1919 celebrations, welcomes the troops home from World War I. When the armistice was announced in November 1918, Mayor Lou Zurmuehlen got out of bed and ordered the fire department to drive through the streets with sirens blaring, and the city gave the returning soldiers a parade down Broadway that has not been surpassed since.

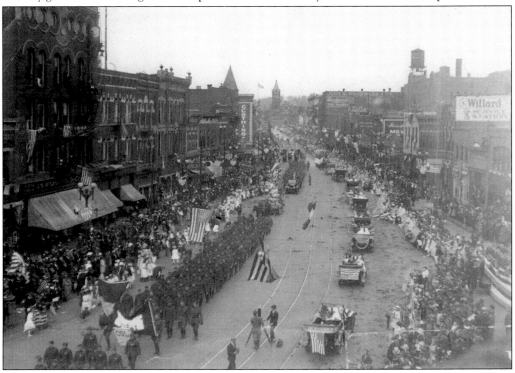

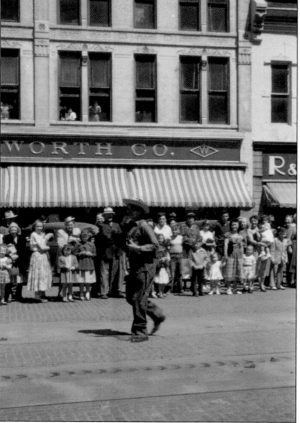

The cat section and a boy and his chicken are seen during the 1951 Council Bluffs Pet Parade. Over 800 youngsters and a menagerie of animals participated that year. The annual event was organized in 1936 by longtime Council Bluffs pound master Chris Christensen, who had immigrated from Denmark in 1911, kept a small zoo at his home on North Eighth Street, and advocated that every child should have a pet of their own. He died in 1954 at the age of 63.

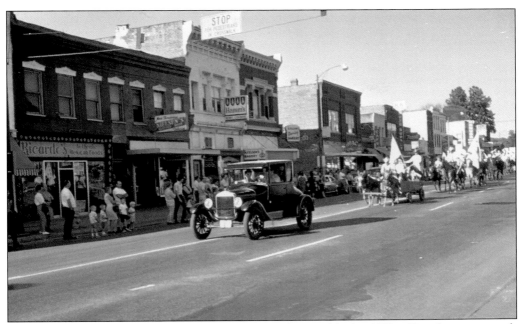

The 1969 Labor Day parade makes its way down the 100 block of West Broadway past such businesses as Ricardo's Mexican Food, Nielsen's Clothes, the Broadway Lounge, Axelson's Danish Bakery, and Dee's Cafe. (Courtesy of Robert Warner Sr.)

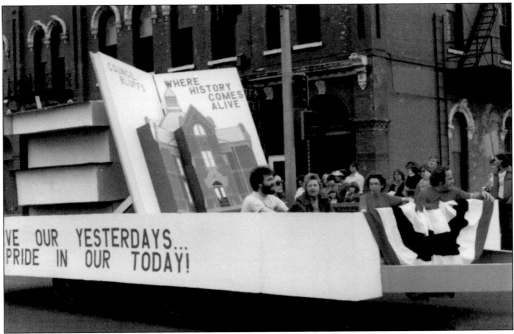

From left to right, Steve Jensen, Sandy Jensen, Peedee Evans, Elaine Van Houten, and Bob Pashek are on the Historical Society float as it rolls past the Ogden House Hotel at 173 West Broadway.

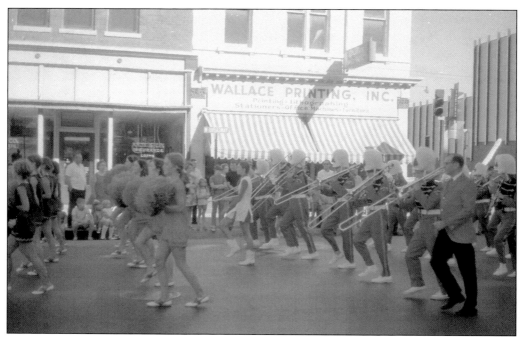

The Abraham Lincoln High School marching band makes its way past the 100 block of West Broadway during the 1969 Labor Day parade (below) and past Wallace Printing at 200 West Broadway in 1970. (Courtesy of Robert Warner Sr.)

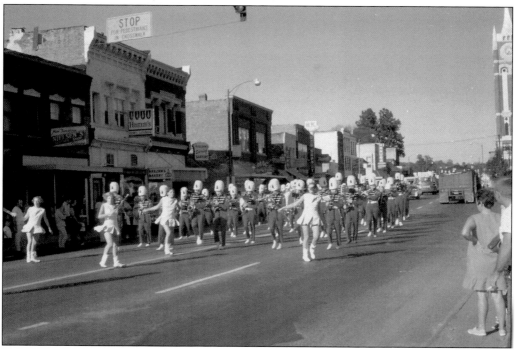

Six

People and Personalities

In 1909, Judge Horace Deemer declared that "from the earliest times what is known as Council Bluffs had a cosmopolitan population, coming from God knows where, adventurers, soldiers of fortune, hunters, traders, gamblers, and the usual nondescript class found on the outposts of civilization." All of them and many more found their way down Broadway, the street where Brigham Young was introduced as the second president of the Mormon Church and where the Potter Christ paraded on a donkey declaring himself the son of God. It was the street where Abraham Lincoln questioned Grenville Dodge on the best route for the transcontinental railroad back in 1859 and where Amelia Bloomer crusaded for women's rights while Canada Bill Jones bilked travelers out of everything he could and one-armed Charlie Stebbins ran the faro bank at the Hoffman House. Mr. Laskowski raised and sold vegetables from his home on North Broadway for years, former slave Lee Moore drove his horse-drawn junk wagon, and where Earl Limerick was stabbed in the chest with an ice-pick at the Diamond, pulled it out, and chased his assailant up the street. The following individuals are just a handful of the many colorful people and personalities who made Broadway and Council Bluffs what it is today.

Francis Guittar was employed by the American Fur Company when he first arrived at Traders Point on the banks of the Missouri in the 1820s. After the 1852 floods, he moved north to Kanesville and opened a store in a log cabin on West Broadway and Main Street. His son Theodore was later elected constable of Council Bluffs and sheriff of Pottawattamie County. (Courtesy of the Council Bluffs Public Library.)

Frank Street was born in 1819 and joined the gold rush to California in 1850. He settled in Council Bluffs in 1852, was elected county judge, and served as register at the U.S. Land Office during the 1860s. Street's addition at West Broadway and Twenty-fourth Street was dubbed "Streetsville," and the appropriately named Frank Street bisects East Broadway. (Courtesy of the Council Bluffs Public Library.)

Junius Palmer worked as a butcher near Coatesville, Pennsylvania, before he moved to Council Bluffs in 1854. He built the Palmer Block on the northwest corner of West Broadway and Sixth Street and also the nearby Concert Hall where Abraham Lincoln spoke in 1859. He was elected mayor three times in the 1860s and had a real estate office on West Broadway. (Courtesy of the Council Bluffs Public Library.)

Pennsylvanian John Baldwin married Jane Hunter in 1843 and came to Council Bluffs a decade later. He was elected to the Iowa legislature in 1854 and went into the banking, land, and grain business with Grenville Dodge in 1856. In 1877, Baldwin took over the Ogden Hotel, was superintendent of the Broadway Street Railway, and mayor of Council Bluffs. (Courtesy of the Council Bluffs Public Library.)

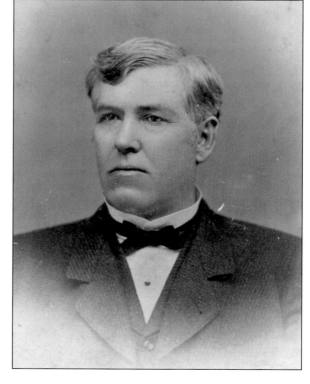

John and Anna Clausen were German immigrants who were married in 1856, and "Honest John" opened the "One-Horse Grocery" in a log cabin at West Broadway and Park Avenue the next year. John served five terms as city treasurer and was later Pottawattamie County auditor. He became an agricultural implement dealer at 100 West Broadway and established Clausen's Transfer on South Sixth Street. The Clausen home at 407 East Broadway was built on the site of Caldwell's Potawatomi Indian village and was where he died on August 26, 1900. (Courtesy of the Council Bluffs Public Library.)

Frank Nick and Louie Shock are in front of the First Ward Meat Market and Frank Street Delicatessen at 608 East Broadway. (Courtesy of Kathleen Rollins.)

Louis Zurmuehlen was mayor of Council Bluffs from 1918 to 1923. He started out as a clerk at Eiseman's, married the daughter of John Bennett in 1896, and went into business with Pat Gunnoude in a cigar store at 516 West Broadway. He was killed in a 1930 automobile accident, and his wife, Georgia, took over the business, then located at 407 West Broadway. (Courtesy of the Council Bluffs Public Library.)

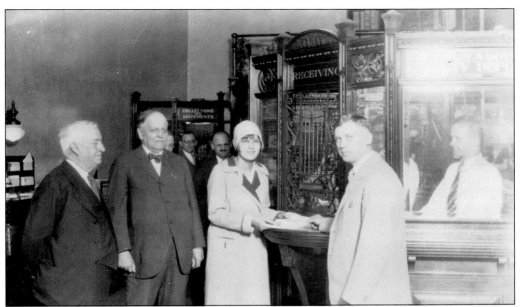

This May 1930 photograph is of Helen Jensen, winner of the National Spelling Contest in Washington, D.C., depositing her $1,000 prize at the Council Bluffs Savings Bank at West Broadway and Pearl Street as bank officers, from left to right, John Woodward, Charles Beno, and B. A. Gronstal look on. (Courtesy of the Council Bluffs Public Library.)

Restaurant proprietor Joe Ewald is on the right with an unknown employee at Ewald's Drive-In at West Broadway and Fifteenth Street.

www.arcadiapublishing.com

Discover books about the town where you grew up, the cities where your friends and families live, the town where your parents met, or even that retirement spot you've been dreaming about. Our Web site provides history lovers with exclusive deals, advanced notification about new titles, e-mail alerts of author events, and much more.

Arcadia Publishing, the leading local history publisher in the United States, is committed to making history accessible and meaningful through publishing books that celebrate and preserve the heritage of America's people and places. Consistent with our mission to preserve history on a local level, this book was printed in South Carolina on American-made paper and manufactured entirely in the United States.

This book carries the accredited Forest Stewardship Council (FSC) label and is printed on 100 percent FSC-certified paper. Products carrying the FSC label are independently certified to assure consumers that they come from forests that are managed to meet the social, economic, and ecological needs of present and future generations.

Mixed Sources
Product group from well-managed forests and other controlled sources

Cert no. SW-COC-001530
www.fsc.org
© 1996 Forest Stewardship Council

Find Your Place in History.